Take ` Selfie Seriously

LAURENCE KING

Published in 2021
by Laurence King Publishing
361–373 City Road
London EC1V 1LR
United Kingdom
Tel: +44 20 7841 6900
Email: enquiries@laurenceking.com
www.laurenceking.com

A catalogue record for this book is available from
the British Library.

Senior editor: Andrew Roff
Senior production controller: Elina Pissioti
Vector line drawings: Akio Morishima

ISBN: 978-1-78627-904-0

Printed in China

Laurence King Publishing is committed to
ethical and sustainable production. We are
proud participants in the Book Chain Project®.
bookchainproject.com

Take Your Selfie Seriously

The Advanced Selfie and Self-Portrait Handbook

Sorelle Amore

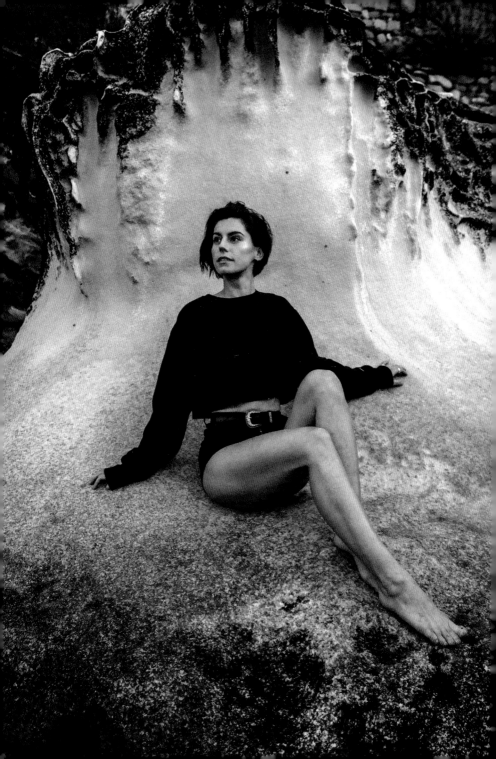

Contents

Introduction: Necessity and the creation of a new art form

My personal journey with self-portraits started by accident. Although I had been a photographer for about two years, I wasn't a professional. Through an internship and a ton of practice, I spent time soaking up as much knowledge as I could from behind a camera. I attempted to capture the beauty of Mother Nature, and took endless photographs of other women. It was during my time photographing women that I honed my skill at teaching them how to pose, in order to bring out their best features and, in turn, help them fall in love with images of themselves. This, I think, is what became one of the most important parts of learning to take great shots of myself.

However, things were still fairly normal in my photographic journey, until one very specific fairy-tale event in my life: I landed a job that required me to travel full-time around the world for three months, staying in luxurious homes in a dozen countries. Yep, terrible, I know! The thing was, I was required to shoot beautiful images not only of these homes, but also of myself enjoying them. And, unfortunately for me, no professional photographer or 'plus one' would be coming with me. Since a simple front-camera selfie would definitely not cut it in the quality department, I needed to learn how to capture myself in these magnificent homes in a way that would do them justice.

When I began, I was convinced I wasn't capable of taking a good photo of myself. I thought I was too tall, lanky and awkward, with a giant mouth. I shied away from being in front of the camera. But necessity was the mother of invention. I practised. I played. I experimented. I learned. As you may experience yourself, the beginning of my journey was not smooth, and I looked like a scarecrow at best. But a little voice told me to stick with it. So I took another photo, and another, and another, with the slim belief in the back of my mind that maybe, just maybe, I'd one day end up with images of myself that I wouldn't just like, I'd *love*.

In a relatively short time I figured out how to take images of myself that were worthy of inclusion in a high-fashion magazine, shot with nothing more than a camera and a few simple tools. (Mind you, I had zero experience being a model, and my experience behind a camera was still fairly limited). I ended up naming my method of self-photography the 'Advanced Selfie', because I wanted to make the process seem less serious (after all, in the end, learning to take your own photo is just a fun exercise), and also because I found the name wildly hilarious.

Fast-forward two years and I've created more than 1,000 of these self-photography art pieces (which can be found on Instagram @sorelleamore), serving as both photographer and subject. The images have obviously been well received, as my Instagram audience has grown to over half a million followers at the time of writing. My perseverance has brought me to a place where millions of people have watched my videos on the subject, I've been published in media outlets around the world, and now you're reading this as I pass my artistic skills on to you.

I've also created the Advanced Selfie University (see www.advancedselfie.co), where I've so far taught over 4,500 students how to perfect my method of stunning self-

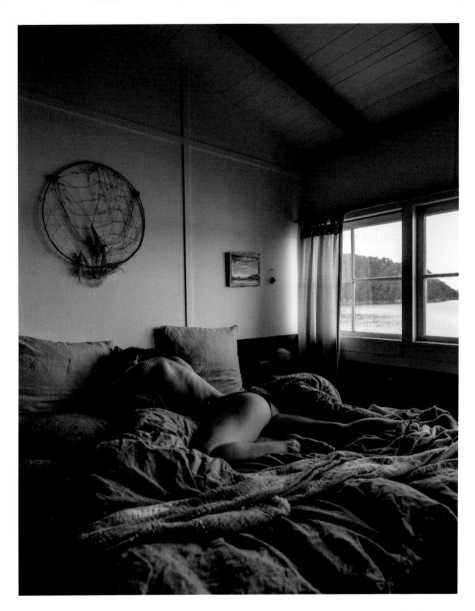

When I started my Advanced Selfie journey, I was strongly under the impression that I couldn't photograph well. A long history of bad photos of me were confirmation of that. With desperation in my heart and a tiny glimmer of hope, I started photographing myself in secret, with huge embarrassment, hoping against hope for results that would prove me wrong. Luckily, they did.

photography. My videos on YouTube (where I've amassed an audience of 1 million people) on the subjects of self-portraits, photography and posing have been viewed more than 35 million times, and the hashtag #AdvancedSelfie on Instagram has been used in more than 150,000 images. I breathed life into the Advanced Selfie, but since then it's taken on a life of its own.

It's strange to say it, but part of my job is to take photos of myself, and teach others how to do the same. Twenty years ago that might have sounded like a far-fetched thing to do for a living, but in today's digital world, practising an art form like this as a job is definitely not as abnormal (even though it does still raise some eyebrows).

A *job*, sure. But an *art form*? Surely not. Well, just give me a chance. The possibilities of expressing yourself in this way are endless. You just have to get the basics down, and maybe learn a little confidence, and then the journey of exploration and infinite creativity will open up for you. When I began, I couldn't have imagined where learning to take self-portraits would lead me. And with that in mind, I encourage you to start. Just *start*.

I'm beyond thankful that you chose to pick up this book and let me share my art with you. Because this art form has transformed my life, and I truly hope it does the same for you. You're unstoppable – I believe in you!

And with that, let's begin …

Sorelle Amore

x

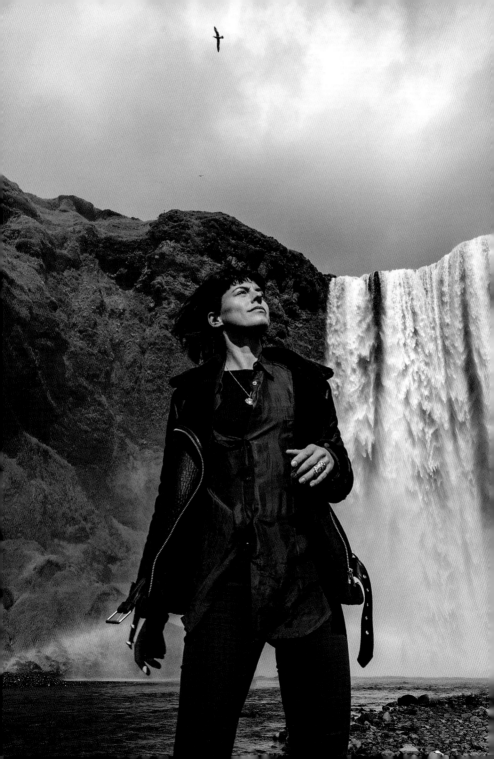

Change Your Outlook

The self-portrait as art

When I speak to others about taking self-portraits, eyebrows are raised and eyes are rolled (I can even tell if there is an internal eye roll). It's easy to assume that self-portraits are nothing more than vanity, but, having studied the art form for years now, I've learned that capturing ourselves in art is something that's been going on for as long as our species has a recorded history.

Humans are obsessed with the idea of capturing their presence in the history of time. Initially, this was expressed by scratching simple drawings on to the walls of caves, but over time it evolved into inscribing images of ourselves on papyrus, slapping paint on to canvas, remembering our lives with words on paper and, eventually, the modern art form of photography. We've always wanted to preserve a part of ourselves that will live on long after we draw our last breath.

Beyond this, self-portraits are a way for us to study ourselves and improve the way others perceive us. Often, when we are at the mercy of someone else's camera shutter, we have little control over the result. And most people find it discouraging to see themselves in a not-so-flattering light.

Undertaking the study and mastery of self-portraiture allows you to enhance your best angles. Just like a sculptor accentuating the curves of his model in stone, or a painter revealing her subject on canvas in the perfect light, you will learn what makes you stand out on camera, and how to avoid those angles that don't make your features pop.

It may not be a definition that holds up with art scholars, but when I think about the self-portrait in this way, I can't help but see it as art. Like any art form, it requires the right

Alexandra Nowak
The lighting, the props, the outfit, the facial expression, the pose – all these parts come together in this self-portrait by Nowak, *Up to Mars*. It shares a compelling story, stops the viewer in their tracks and allows you to shape your own interpretation, too – all the qualities of a great piece of art. **@lex_nowak**

execution, but you'll learn how to do this over time with exercises in self-awareness and self-improvement.

The result? More than just great photographs of yourself. You'll see yourself in a fresh light and with an aura of positivity, and all because you learned how to harness a new art form to capture yourself on a screen. The ripples of that new vision of yourself will allow you to create bigger and better things in every part of your life, and place yourself in the world like the perfect subject you are.

Selfie don'ts

When you think of a selfie, you tend to think of the images you see all too often on social media: close-up photos, perhaps a cheeky pout, with hands, phones or a selfie stick in view. But the Advanced Selfie is essentially the opposite of the regular selfie.

It's all about art and creativity. It doesn't rely on a specific type of beauty, size, gender, shape, nationality or ethnicity. The limitations are only those of the mind. It allows you to capture feelings and create a story with your imagery to support the notion that a picture is worth a thousand words. (Honestly, no regular selfie can claim this.)

An Advanced Selfie doesn't seek perfection, either, and it's not about you trying to be something you're not. It is about exploration. Lose yourself in the process of creation and bring a complex vision to life, whether with props, the background, the best lighting or emotion. This is when your work transforms from simplistic to something that can be respected.

Once you've learned some of the techniques in this book, you'll break open your notion of what a selfie can be. Here are some selfie don'ts that I'd like you to steer clear of.

Arm in view

All too often we see selfies with an arm in the shot, clearly taking the photo. Invest in a tripod and a remote trigger (see pages 68 and 70) and your shots will no longer reveal any hint of being self-portraits.

Camera in mirror

People do this either to get full-body shots or to beat the poor resolution on selfie mode. A timer and a remote trigger will enable you to take full-body shots, and a DSLR camera will give the best resolution.

Minor effort

Turning your camera to selfie mode and pulling a quick pose might take a couple of minutes. But if you lose yourself in the process of bringing a complex vision to life, your selfies will reach another level.

Why the Advanced Selfie will change your world

- We all love great photos of ourselves. They raise our self-esteem and help us tackle life better in general. Feeling good about our appearance gives us a boost that money can't buy.

- When you feel good about yourself, you perform better in business, with family, in relationships and socially. That means you'll feel better mentally, and live an objectively better life. So I could say that taking great Advanced Selfies is literally improving lives!

- Having great photos of yourself will make you look more composed – in life, on dating apps, on Instagram and in business. Like it or not, people will judge you instantly from your pictures. What impression are you giving with the photos you share of yourself?

- For artists/models/actors/musicians/influencers – you need great images to sell yourself as a brand. With the Advanced Selfie, you don't need to hire photographers to do it for you, so you'll save a ton of cash! Actually, this also applies to anyone who has their own business, including entrepreneurs, dentists, doctors, estate agents, freelancers and anyone else in between. Basically, anyone with a public image can benefit from this book.

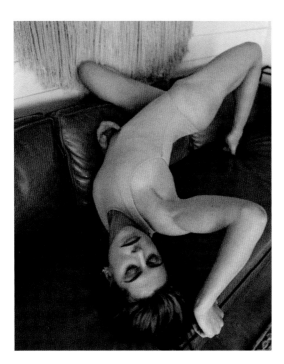

Why is this concept so profound? It allows us to uncover beauty in every person and celebrate self through creative expression.

- You'll save money by taking your own photographs, instead of using photographers who might not even capture you in a way you'd like to be presented.

- You'll take much better travel photos. In the future, you'll be able to look back on amazing adventures with friends and family, knowing the beautiful shots you captured truly reflect the experiences you had.

- You'll end up with stunning images showcasing the best side of yourself, that you can use to impress your current or future partner, spouse, children, grandchildren, other family and friends. Images that your children can pass on to their children. It's a great way to capture your history and any special moments in your unique timeline.

- If you're a photographer already, you'll understand your art better, including how to pose your clients, how to help them to overcome their fears, how to make them more comfortable and how to get the best results out of them during your shoots. A better subject means better images, and in turn for you that means more repeat business and referrals – more business, and more cash in your pocket.

- Since starting my self-portraits, I've become comfortable in front of the camera, even though at first I was mortified to take my own photos. I've worked out how to present myself better to the world in everyday life, not just in front of the camera. I now know what outfits look good on me, what hairstyles suit me best, and how to hold myself, which positively affects my confidence and posture. Taking Advanced Selfies has given me more insight into myself than I ever thought I'd have. It's been a weird and unexpected deep-dive into my own personal development.

Reinvent yourself

Ever felt trapped by your own personality? I have often felt trapped inside a personality that has been created during my lifetime. I think it's something we all struggle with, and it's difficult to know how to break away from that personality, to allow new parts of our higher self to shine through or to express ourselves more creatively. Perhaps this is why in the modern age we're attracted to celebrities who change their appearance and attitude constantly, because that allows us to live vicariously through them.

Cinthya Bufano
Using a mirror is a clever way to add another layer of reinvention into your self-portrait just as Bufano does here. What's the alternative reality that's being reflected?
@adrian128k

Self-portraiture, when used as an artistic tool, can become a way for you to express the depths of your soul. My personal images are often extremely dark and moody, with an element of contemplation, and sometimes glamorous and feminine. This is quite the opposite of the way most people know me in 'real' life, when I am very bubbly, smily, a bit ridiculous, a jokester and quite a tomboy. I have no desire to capture images that reflect this side of me, since I live that part of myself fully every day.

The self-portrait can be an opportunity to express yourself differently, or more fully, if you so choose. In fact, I encourage you to look at it in this way. For example, if you have been told repeatedly that you're a certain type – 'You're very shy', for example – no doubt you'll want to explore the possibility of being the opposite in your images, even if it's just to see how that new trait fits. An interesting thing may happen. The new personality traits you choose to embody in your photography may start to seep into your daily life, and that could benefit you in a multitude of ways.

You choose your image

Friends, family, colleagues and others we interact with regularly tend to paint us with a certain brush, based on who they think we are. It can be difficult to change people's minds, or edit the way they see you. But the beauty of self-portraiture, when combined with social media, is that you can create an online version of yourself that reflects how *you* want to be seen. If you're running a business or dipping your toes into the world of being an influencer, your audience will have

no choice but to see you as confident, if that's what your images portray.

It's the same when you're seeking a partner online, through internet dating or an app such as Tinder. Of course you want to showcase the best version of yourself to the world, and because you're seeking out those who don't yet know you deeply, it's a chance to present the version of yourself that you want them to see.

Now, of course, I'm not saying that you should show yourself as something you're not. But when it comes to traits such as confidence, we all have them within us inherently, but we may be a little out of practice in embodying them. Your images can become a physical manifestation of the sparks of confidence and fierceness that are inside you, and will serve as a platform for the alter-ego version of yourself that will be created in the real world.

The challenges you'll face

Trust me when I say that you'll probably feel pretty awkward when you start taking your own self-portraits. As with anything you've never done before, you'll suck at it a little.

There's a lot to think about: lighting, the way you position your body, the angles of your face, your camera's settings and position, how the background is framed, how the body is framed, the rules of photography, clothing, your facial expression, the emotion you're trying to portray, and storytelling. And you've got to try and get all this right

Lenke Magyary
In this striking, high-action image, the result of a lengthy photoshoot, Magyary has considered every element: hairstyle, facial expression, clothing and background. She even made the props herself.
@lenkexplores

in the few seconds between when you press the shutter delay on your camera remote, and when the picture is taken.

At first, you might spend an hour shooting to get one usable photo. You might fill up a memory card or your phone storage and not have a single shot you like. And you might end up feeling as though you've wasted a ton of time.

It's going to be *very* messy initially, and you might find yourself coming close to giving up, wondering why you're even bothering with a practice so seemingly vain as learning the art of the self-portrait. Even after several thousand images, I still sometimes have this very story running through my brain when things aren't working out.

Even after everything you'll learn in this book, your first images may be unflattering, cheesy or dull. And because you've been conditioned by the media and TV to believe that the whole world is supposed to look like a catwalk-ready supermodel at all times, you may start thinking you're the exception to the rule, and that there's no way you can possibly be captured well on film. (Allow me to let you in on a secret: you'd be wrong.)

Years ago I was lucky enough to intern in the world-class Sherbet Birdie Photography Studio in Sydney, Australia, where we took so-called everyday people and transformed them beyond their wildest dreams in photographs. Very often, clients would walk in convinced that it was impossible to take a good photo of them, but they would pray to the heavens that they would be proved wrong by the end of the day. Lo and behold, virtually every client would almost fall off their chair in shock and joy when they saw how we were able to capture them.

Through knowing how to capture someone using the art of the camera (considering lighting, the settings and the background), and what would bring out their beauty in a photograph (including posing, the wardrobe, hair and make-up), we were able to shift their self-image completely, even

when they believed there was no hope. It all came down to skill learned through repetition, and that is something you'll master as you put into practice the fundamentals of taking an exceptional self-portrait.

Yes, it may take you some time. Yes, it may take you hours at first even to get a single shot that you love. But with enough practice, you'll eventually be able to set up the minimum of gear and capture an image that you'll love in as little as a few minutes, that will boost your confidence and fill your soul with joy. Like anything in this human experience, it may start out challenging, but eventually it will become a streamlined, enjoyable, satisfying process that will result in artworks you can't wait to share with the world.

Realistic expectations

It's time for a reality check. Despite all I've just said, I must state at this point that some people just have it naturally easy behind the camera. There are the Angelina Jolies, the George Clooneys and the Winnie Harlows of the world, at whom many of us look with envious eyes, wishing we had those cheekbones, or those eyes, or that smile.

But we must always remember that we've all been granted our own special tools in the genetic toolkit we were born with, and it's up to us to make that beauty shine. Even if you don't see people who look like you promoted in the media or on billboards, it doesn't mean there's anything wrong with the skin you were born in. In fact, in today's world, where uniqueness can be social currency, it can actually be of huge benefit.

If your look is mega-unique and not like any seen in mainstream media, congratulations! But it doesn't really matter what I say; it's up to you to decide whether to praise this part of yourself, or shun it.

It's important to understand objectively what makes you beautiful, special, unique or different, so that you can be overjoyed when you capture that unique gift on camera. You may not look like Hailey Bieber or Tyson Beckford or whoever else you idolize, but at least you will know when you've snapped a fantastic photo of *you*. However, if you don't have a realistic view of what makes you beautiful, or what makes you stand out, you will be forever disappointed with what you see in your images.

Skill in Advanced Selfies is all about being able to look at yourself objectively and lovingly and assess what you have or haven't been given, without judgement. Accepting and seeing your beauty as you are instead of fighting it will not only give you inner peace, but also help you immensely in your journey of self-photography.

How much editing is too much?

Many people have told me that when they see my images, they think 'Whoa! She's beautiful!' I didn't get told this very often just a few years back. I'm not saying I haven't been given a few nice features, but I didn't really spend time studying my physical strengths and weaknesses. Because I wasn't very aware of my own features, I had the wrong haircuts most of my life, I wore the wrong clothes, my make-up was always off and the

way I carried my body was strange. I wasn't really at fault; I just didn't know any better. I didn't pay much attention to working around my prominent nose, my swimmer's shoulders, my small and bony chest, or my giant grin, which can sometimes make me look like a bit of a clown. (In the same breath, however, I'll be quick to say that I adore that giant smile.)

But since mastering the art of the Advanced Selfie, I know how to use these features to look impressive in photos, and, if I want to, in real life as well. My audience on Instagram constantly tell me that they appreciate the fact I can look like a total slob in Instagram Stories with messy hair, no make-up, sleepy eyes and baggy clothes, but then somehow, BAM! I post another polished photo on my feed. This begs the question: how much modification or editing goes into turning me from the woman my boyfriend wakes up with in the morning to the powerful and 'flawless' being captured and showcased on my Instagram feed?

The beauty of studying the art of the self-portrait is that learning what makes your features pop, or what angles make you seem more confident or powerful, diminishes almost all need for the heavy use of editing tools such as Photoshop. Yes, I do still use Photoshop at times. I use it to slightly alter lighting, or to remove a shadow here and there if I feel my nose has been lit slightly wrong and it makes me look like a bit of a witch. I'm not against these image editing tools, because I think they have their place when it comes to polishing up minor details that nobody else might notice. Like most people, I'm my own worst critic, and there are some things I feel can be adjusted in post production.

However, I don't appreciate the way some advertising agencies and individuals have made it normal to make drastic changes, rendering the finished product so far removed from the original image that the subject is almost

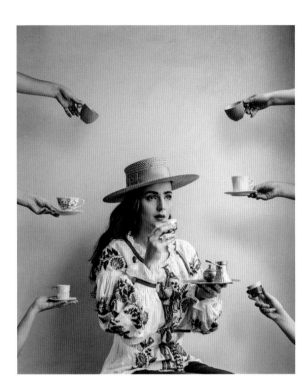

Aida Đapo
Instead of using Photoshop to change your appearance, try using it creatively, as Đapo does here to replicate hands and teacups.
@iddavanmunster

unrecognizable. To me, there's a difference between boosting your own self-confidence and altering the standards of beauty so far that it becomes damaging to our collective self-esteem.

So feel free to use Photoshop to put the finishing touches to your images, if you like, but beware of going too far. You don't want to become addicted to seeing a representation of yourself that's so far beyond who you really are that it becomes fantasy. You'll end up stuck forever striving for something that will never look back at you in a mirror.

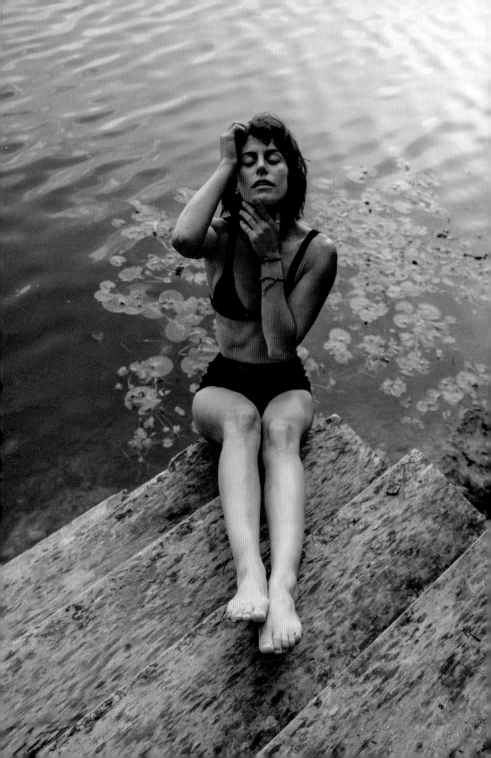

Self-Awareness

Who are you?
Who do you want to create?
How do you want to be seen?

Knowing who you are is a great place to start on your journey with self-portraiture. This method of photography requires a lot of self-awareness and will result in a lot of self-discovery. Once you understand what you love, what you hate and everything else that you are made up of, you can choose which elements to translate into your art.

I have already mentioned highlighting parts of yourself and your personality that you love, but there's so much that can be created with art when you dig into some of the darker or less explored parts of your mind or soul. This is probably where the most powerful images you create will come from, as they will be charged with emotion and power.

Don't limit yourself or your art by thinking that taking self-portraits means you must always share the images. Some of the art you create may show parts of yourself or your emotions that you won't want to make public. That's perfectly fine; just know that not showcasing an image doesn't in any way diminish its power or beauty. This form of expression can sometimes (or always) be for your eyes only, or for the eyes of a loved one.

Here are some examples of visions of your unexpressed self that you might want to bring to life:

- Provocative photography
- Dark photography
- Nude photography
- Heartbroken photography
- Distressed photography
- Role-play costume photography
- Timid or weak photography
- Angry photography
- Fiction-inspired photography
- Medieval history photography

These can all be examples of the shadow self, which in psychology refers to parts of yourself that you haven't fully embraced, or have so far shunned. We all have the capability to feel or think extreme thoughts. Most of us bottle these emotions up and some express these thoughts or feelings behind closed doors in solitude. A lot of us fear rejection or ridicule for feeling this way, or simply we personally fear meeting these 'unacceptable' feelings or thoughts. (I'm not talking about emotions that actually make people act in a dangerous manner!)

The Advanced Selfie is a way to dig into the shadow self, and embrace those parts that are usually hidden. An acknowledged shadow self is a lot safer, since the itch has been scratched and the emotion given time to speak. Unacknowledged and repressed parts of the shadow self have the tendency to bubble up to the surface and explode without warning, sometimes doing serious damage to our mental, physical or spiritual health.

So get that latex on, honey, and start snapping!

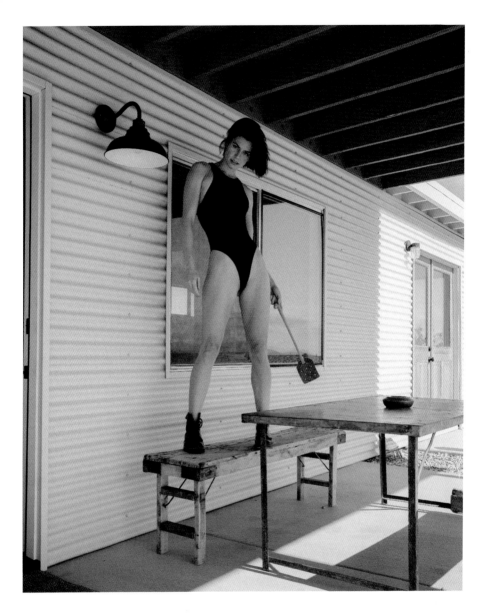

I'm using the power pose here (see page 58), as well as shooting from a lower angle to accentuate my best feature – my legs. A powerful facial expression to match and it feels as though this image allows my alter ego to come out and play.

Assessing yourself: what is your angle?

If knowing who you are inside is the headline band, knowing yourself on the outside is the support act. It's time to get yourself in front of a full-length mirror so that you can start assessing the body that carries you through life. You only require a phone camera at this time.

The selfie camera on most phones is a wide-angle lens. For this reason, don't take the photo too close to your face, as it will widen and distort your features, and not give a true representation of who you actually are. Furthermore, you will feel very odd performing some of the exercises on the following pages and keep in mind that the phone camera in your messy room, with your messy hair isn't going to capture your absolute best right now. It will be raw but we're looking for small hints of what your best angles are. Go easy on yourself.

During this exercise, wear fairly fitted clothing. This will help you separate your body parts more easily, in order to pinpoint exactly when your arm is in the right spot, for example. Let's break down the face and body parts step by step, to help you identify your best angles.

Face assessment

Stand next to a window during daylight for this assessment (natural light is some of the best to photograph yourself in). Take photos of your face from these angles, and ask yourself which do you prefer.

- Your face straight to camera, at 45-degrees, and in profile.

- Both sides of your face, and assess whether you like one side more than the other. Lots of people say they have a 'good' side and a 'bad' side; I prefer my right side, for example. Many professional models are photographed only on one side – even top fashion models. Do a quick online search for pictures of your favourite models, and you'll see that many are captured primarily from just one side.

- With your face tilted slightly up, in a neutral front-on position, and tilted slightly down.

- Your face front on, with your head tilted slightly to your left (ear to shoulder), straight on and tilted slightly to your right.

- With your eyes looking straight into the camera, and then various images of your eyes looking slightly up, slightly down, to the left, to the right and into the 'corners' of the frame.

- Does your face look better if you're laughing, with a big smile, neutral, smiling slightly, smiling with a closed mouth, smiling with an open mouth, with a seductive expression, an inquiring expression, a cute expression, or a strong or fierce look?

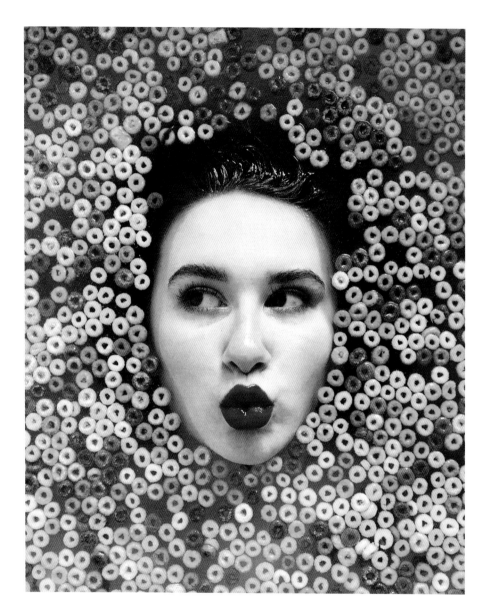

Bronte
Learn to recognize either the part of your face that you like or the angle that works well for you. Of course, having regular features and an oval face doesn't mean you can't take a loopy self-portrait, as Bronte shows here. But, despite the quirkiness of the pose, she emphasizes her lips with a rich colour so that there's no doubt about her favourite feature. **@frombeewithlove**

Once you've assessed all these parts individually, it's time to put your favourites together. Combine your favourite mouth expression with your favourite face angles and your favourite eye expression. Eventually, and with practice, you'll be able quickly and easily to get into your most flattering facial position, which will be a game-changer for your confidence and the way you see yourself in photos.

Not only that, having well-rehearsed 'go-to' facial expressions will prevent you from looking like a deer in headlights whenever someone takes a photo of you.

Body assessment

Which part of your body is your favourite?

Don't try to lie. Everyone has at least one tiny part of themselves that they love. This is not the time to deny yourself the opportunity to love yourself; it's the time to be proud of that part or those parts that you adore. In case you're feeling a little stuck, here are some prompts. Do you like your:

- hands
- breasts
- arms
- legs
- neck
- calves
- butt

The aim of identifying parts of your body that you like is to focus on highlighting them in your photographs with posing, clothing, the environment and more.

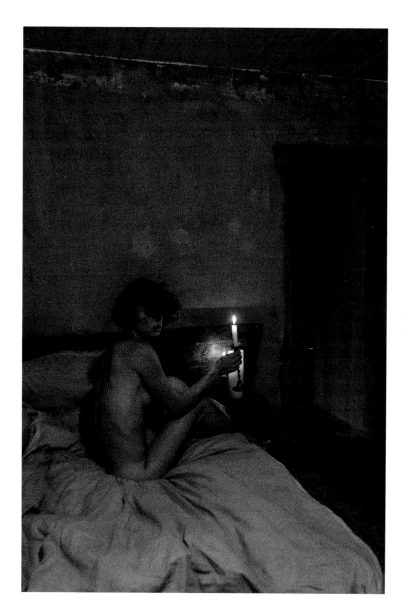

I was always shy of my body, told I wasn't a real woman because of my muscles, wide shoulders and bony chest. To feel undesirable when women are so strongly valued for their looks took its toll. Learning to pose finally let me see myself as a beautiful human, one worthy of love.

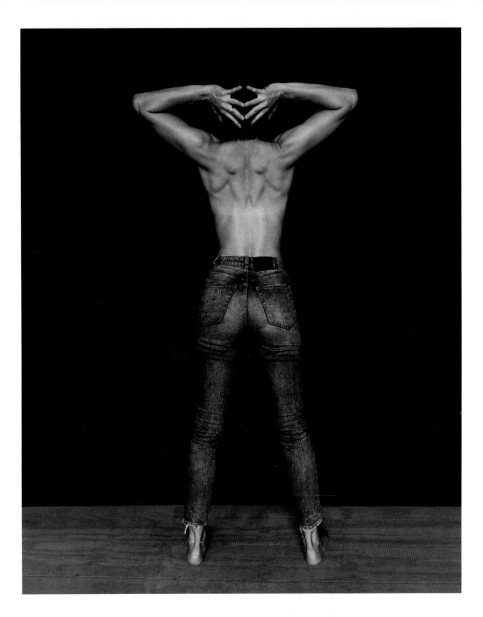

My back has been heavily ridiculed. I was a professional swimmer for eight years, so I have broad shoulders that I used to try to hide – which was obviously impossible. This was a serendipitous snap when I thought, 'Whatever, this is me', flexed and gave it all I'd got. My audience recommended I change it to black and white to emphasize the details even more. Now it's one of my absolute favourites.

Which part of your body is your least favourite?

Most people find it much easier to rattle off all the things we don't love about ourselves. We are *experts* at identifying these parts. Unfortunately, we've all become deeply affected by mass media, whose primary aim it is to make us all feel horrible about every single aspect of ourselves, so that we buy beauty creams, ab rollers, gym memberships and so on.

Still, identifying the parts of your body you don't love so much is important. It's so that you can be aware of them, and ensure that when taking Advanced Selfies you choose poses that give you – more often than not – an image that you love.

Know the flaws you want to hide, and be aware of the attributes you want to amplify. This is the winning combination that every superstar model uses, and that you can use as well when creating your art.

Tips for posing your body

Use these guidelines to give you the best chance of photographing each part of your body well.

Arms

Give each arm space. Lifting the arm slightly away from other parts of your body will prevent squishing, which can expand the arm and make it look larger than it is. Interesting angles for the arms also lend variety to your photos. Avoid bending your arm at the elbow in such a way that your forearm disappears, or your arm will look like a little stump.

Shoulders

Pulling your shoulders back will give you better posture for photos. Just don't do it too much; you're not in the army. A confident posture is good, rigidity isn't.

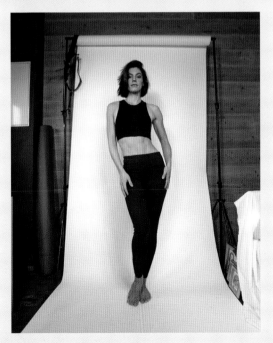

Hips

This is a great part of the body to play around with, especially if you're amplifying the feminine. Curves are often associated with delicate, beautiful, sensual photos. Pushing one hip out to the side and putting most of your weight on it accentuates the body's 's-curve', which works beautifully in photography.

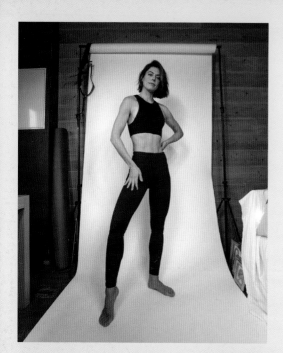

Belly
Suck in the belly a little to
create tension in the abdomen.

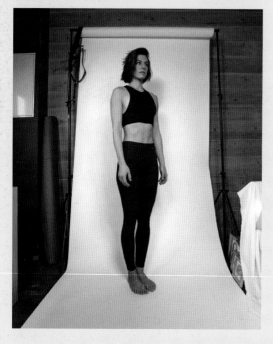

Body angle
Generally, angled 45 degrees
to the camera is best.

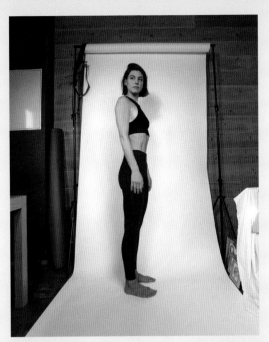

Breasts (if applicable)
Don't be shy, honey! Avoid curling
your torso in and bring your boobs
to the forefront, no matter what size.
All are perfect.

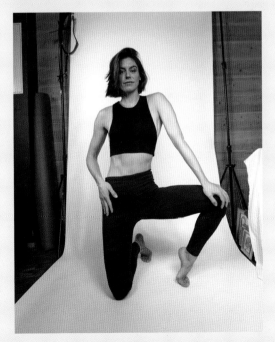

Knees
If you're ever doing a kneeling
pose, show evidence of the rest
of your leg, otherwise it may
look incomplete.

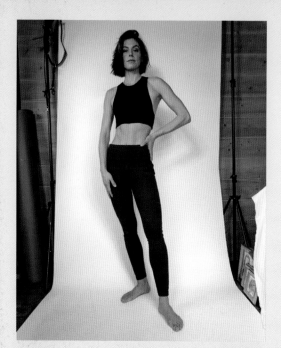

Feet

Pointing your toes slightly more than normal will add a delicate and feminine touch; keeping your feet natural is more common in images highlighting the masculine. Flexing one or both of your feet upwards can give your photo a quirky, artsy touch.

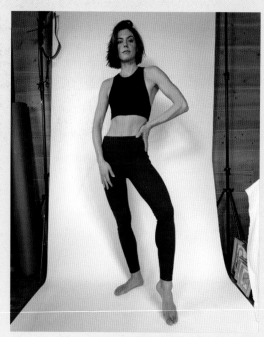

Don't clump your fingers together
Keep your fingers naturally separate instead for a lither feel.

Tips for posing your face

Your face is a landscape of expression and the possibilities are endless. Here are some ideas of what will look engaging in photos and what is best avoided.

Chin forward and down (a little)
This trick works wonders for straight-on photos, and many celebrities use it. It may be only a tiny tweak, but it gives you confidence and makes you look fierce. Try it some time and reap the rewards! Beware, though: don't do it when photographing yourself from the side. You'll look like a turtle.

Smile with the eyes

Following on from the previous point, try the well-known 'smile with your eyes' technique as expounded by the supermodel Tyra Banks. It lifts the corners of your eyes ever so slightly, and adds a killer twinkle that will make everyone swoon.

Relax your lips open

This tip has saved me time and time again. I grind my teeth a lot and clench my jaw, which does not translate well into images. A simple way to combat this is to relax your lips so that they open a tiny bit. This will make some of you look incredible; others may find it makes you look a little dopey (use your judgement!). If you're bordering on dopey, add a tiny smirk to your face in order to lift the corners of your mouth.

Piercing eyes

It's a sad moment when a photo is flawless but the eye expression is disconnected and numb. Engaging the eyes is a must. Try looking through the camera, really piercing through it as if you were looking at someone behind the lens.

Tilt your head

When we engage in conversation, simple body-language cues show that we are listening and engaged. One of these is the subtle head tilt. Watch your friends next time you're having an interesting conversation. It's likely that they will tilt their head slightly forward, or to one side (ear to shoulder). This can translate beautifully to a photograph, and adds a comforting feeling for the viewer.

Fake laugh

The fake (or simulated) laugh is common in images on social media these days. Personally, I'm not a fan, simply because it's so overused. However, there are many times when I really am feeling ecstatic and/or the background calls for a nice big smile. It's important to remember that the perfect self-portrait may not take ten seconds to capture. Sometimes it may take half an hour or more. You will need to learn to conjure up a laugh on command, and for a long time. Forcing myself to laugh (out loud!) makes me feel ridiculous, but more often than not it'll start me laughing for real because I feel so ridiculous. Et voilà! A laughing shot is in the bag.

Fake smiling isn't your friend

There is a big difference between simulated laughing and putting on a fake smile, and the latter really won't fly. Before taking any photo, try to embody the feeling you're trying to portray. A smile must be authentic. If you have to spend five minutes listing everything in life you're grateful for, or remembering a cherished moment with a loved one, to induce a smile, that's what you have to do. Just don't over-smile. It's often a subtle thing we do in panic, in response to having a camera in our face. If you're prone to over-smiling, just being aware of it and relaxing your smile by 20–30 per cent should help you look more natural.

The 'deer in headlights' look

Another sign of panic in photos is to open your eyes extra-wide. This results in you looking scared. If you're prone to this, relax slightly just as the photo is taken. If you're unsure whether you're a culprit of the fake smile, tight jaw or deer-in-headlights look, just ask a brutally honest friend or family member. Hopefully, they'll let you know the truth.

Easy 'go-to' poses

Use these guidelines to give you the best chance of photographing each part of your body well.

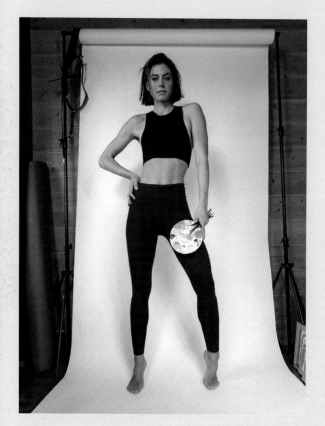

Power pose
An easy 'go-to' pose is simply to stand straight on to the camera with your feet hip-width apart. Try to avoid placing both of your hands on your hips; it can appear a little cheesy, or make you look like Superman. Holding something in one hand (such as a whip or a palette) and keeping the other relaxed will show that you mean business.

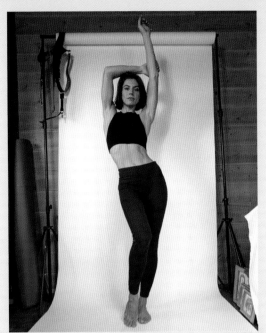

Curvy pose

This one is to accentuate your curves. Standing straight on to the camera, put your whole weight on one leg, pop out a hip to one side and push into it further. Try to keep your shoulders and head as close to your vertical centre point as possible, to create more interesting lines. Lift your arms and create unusual shapes – possibly one arm up in the air and one slightly bent – to add more curves.

45 degrees to camera, one leg forward

This is a pose that looks good on most people. Stand in front of the camera with your feet together. Then simply rotate your feet 45 degrees away from the camera and extend your front leg towards the camera. This will add flattering dimensions to your body (since straight on can be a little boxy), and the leg extension will make your legs look longer. For even more length, lift your front heel off the ground. Alternatively, lift the front leg off the ground and bend it back at the knee with a pointed toe. It's an easy and cute pose. Gents, or those not attracted to feminine poses, shouldn't shy away from this pose. A 45-degree stance with the tips of your hands in your pockets (leave the thumbs out) or your arms crossed is a strong pose.

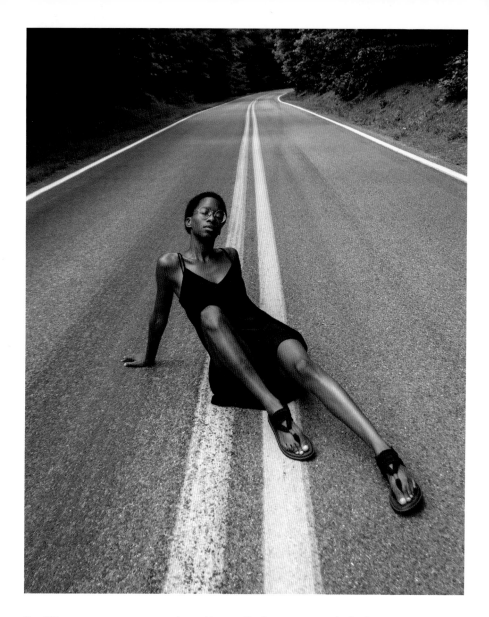

Tana O'Hara
This deceptively relaxed pose has been very carefully considered. O'Hara emphasizes the lines of her legs and torso, and her figure seems to be picked up and carried into the distance by the yellow lines of the road. The tilt of her head, chin raised and eyes down, gives the pose a sassy edge. It all suggests someone on a personal journey. **@tanaohara**

What your poses say about you

Once you've identified your favourite body parts, you can start putting your best assets forward into a pose. Keep in mind, the pose tells half of the story of the image. The pose might be adorable, but if it isn't in line with the picture you're trying to create, stay away from it for the good of your public image. For example, the most common face pose I see on Instagram is looking down and smiling. This may be cute, but it doesn't signify strength; it's shy and coy.

What is your colour?

Different colours work better for different types of skin than others. Wearing some shades of clothing may make you look like a zombie; others may give your skin a strange orange glow; yet others will make your eye colour zing. It's important to spend some time identifying which colours work best on you. Once you know, incorporate them into your wardrobe, the backdrop of your photographs and the editing of your images.

Here is a general guide. I would also advise spending some time researching this topic online, to really home in on what colours will make your skin pop, and which won't do you any favours.

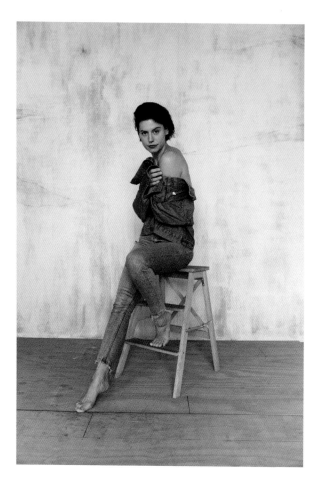

Immersing my fair skin in the cool tones of the denim and the slate-grey background is perfect for accentuating my best features, working in harmony to create a delicate image that is very pleasing to the eye.

Fair/pale skin

Generally, those who turn a bright lobster shade when spending too much time in the sun, or those who freckle instead of tan. Usually blondes, redheads or individuals with light brown hair.

Find neutral hues of clothing, such as darker beige, olive green, khaki, slate grey and burgundy, that contrast with your skin tone but also bring colour to your complexion. Generally, avoid pastel colours, which can cause you to look washed out.

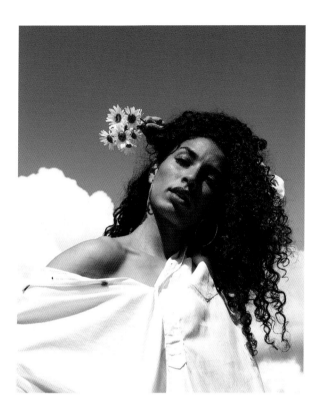

Mari Moore
The deep blue of the sky and the white clouds and clothing really work with the medium skin tone of the model, influencer and entrepreneur Mari Moore. **@mari.moore_**

Olive/medium skin

If you generally tan to a pleasing golden glow in the sun, this is probably you.

Opt for shades that are a little darker or lighter, rather than going for the middle ground. For example, if you're trying on blue, go for a light or dark blue. Avoid colours that contain a lot of yellow or green; your skin probably has this undertone, so they won't do you any favours.

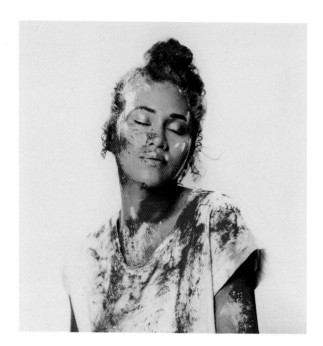

Maya Washington
With darker skin tones like Washington's, you can go with 'zingy' bright colours like magenta and the royal blue used here. Get messy with colour – powder it on your skin and hair. Here, less is more and the simple background further heightens the bright colours.
@mayasworld

Dark skin

Caramel, coffee and chocolate brown.

The world is your oyster, and you can easily pull off almost all colours, with the exception of those that match your skin tone exactly. You can really take advantage of bright colours that leave others looking washed out, such as magenta and lime green.

As I mentioned, the above should be considered only as a guideline. For example, some people with dark colouring actually have a 'cool' undertone to their skin, which will affect how good they look in certain colours.

Finally, when it comes to the idea of the 'right colours for you': as always, rules are made to be broken. If you adore a certain colour that isn't advised for your skin tone, there

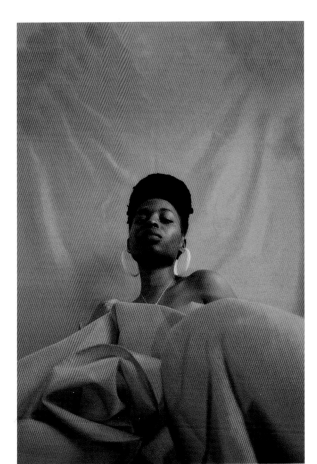

Charlène Irakoze
These colours are bright and confident – just as Irakoze appears. Clashing pinks and oranges give a tropical vibe that is picked up by the bright yellow earrings and colourful make-up.
@cha.rlene_

are always hacks. Perhaps you could add a scarf in that shade, or wear your favourite colour on your bottom half, which is much easier to make work because it's further from your face.

Above all, though, fashion is personal expression. Sometimes you've just gotta wear what makes you happy, regardless of the colour.

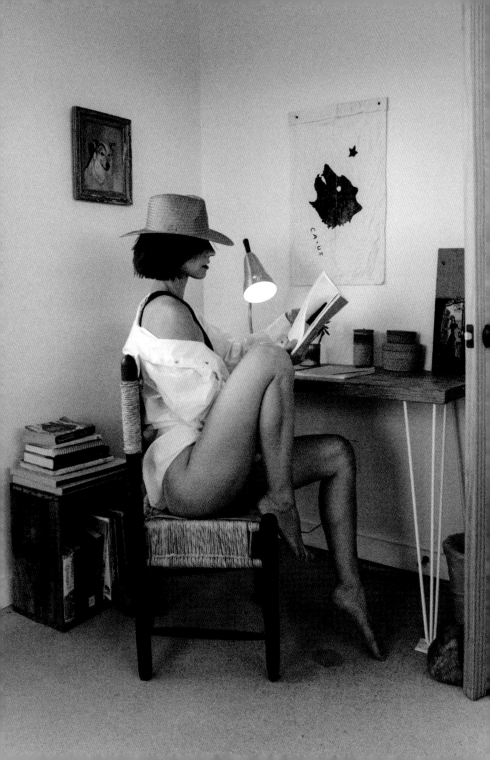

Logistics

Equipment

You can pull off a good self-portrait with almost any budget, and there are both cheap and high-end options when it comes to choosing your equipment.

For beginners

Smartphone

Generally, the more expensive the phone, the better its internal camera will be. I prefer devices with a voice trigger, so that you don't have to move from your pose or set a timer to take the shot. Alternatively, a Bluetooth remote trigger connected to your phone (depending on compatibility) could also do the job (see below).

Tripod and mount

It's possible to attach almost any smartphone to almost any tripod, although you will need the right mount for your equipment. I recommend getting a tripod that will extend to your shoulder height, with a head that can be tilted in all directions, especially down. This will give you the option to take photos lying on the ground, which allows a variety of interesting angles. If a tripod is beyond your budget, you can use books, nearby fences or anything else you can think of to prop up your phone. However, your photography will probably suffer, since you'll be significantly limited in the range of angles you'll be able to achieve.

For the more advanced shooter

DSLR or mirrorless camera

Ideally, this should allow you to connect via an app to your smartphone, so that your phone can act as a remote trigger. The advantage of this is that you'll be able to see what your camera sees on the screen of your phone via the app, so you can pose yourself more easily to ensure a perfect composition. Professional cameras take RAW files, so you can manipulate colour very precisely in editing programs to get it to your desired aesthetic mood. They produce high-megapixel images, so you can zoom in on and crop a portion of the image while maintaining the quality of the photo. Professional cameras also perform better in difficult light conditions, so you can take photographs in strong light or near darkness. Photographing indoors with limited lighting – another circumstance where the mobile-phone camera might struggle – is also possible. The range of lenses available with professional cameras means that the full creativity spectrum is open to you.

My preferred lenses

16–35mm I use this lens when I want to capture the full environment and me posing in it. It's a very versatile lens, and one of my favourites. Keep in mind that this lens distorts objects that are close to the edge of the shot, so keep yourself near the middle of the frame and avoid using this lens for close-up shots: it will not make you look your best.

24–70mm This lens is perfect for close-up shots. The best trick is to take your camera far back, zoom all the way in and then physically move back from the camera until you're happy with the framing. This zoom-in motion helps to compress facial features and flatters them, narrowing noses and ears, for example. It's a camera trick to keep in mind at all times.

Drone

If you want to level up your Advanced Selfies and knock everyone's socks off, drones are great. They will let you take unreal top-down photos that no one will ever believe are self-portraits.

Lens filters

I used to believe these weren't that important, but I was very wrong. There are a range of filters for a vast number of needs, but my personal favourite is a Circular Polarizer, because it helps to preserve the details in the highlights. Since I'm a major fan of shooting in harsh midday sun, the investment was absolutely worth it for me.

Remote trigger

If your camera doesn't allow wireless connection via a smartphone app, look for a third-party remote trigger instead. It'll do a similar job as your phone, although you probably won't be able to look through your camera via your phone screen.

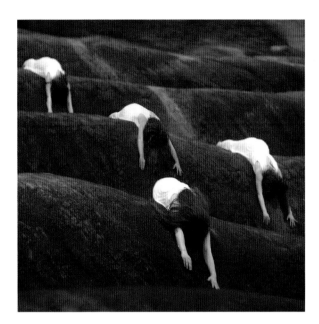

Patty Maher
This self-portrait, *The Hills*, was taken in a public place with people all around, so it had to be conceptualized beforehand. Maher did a few test shots to pin down the exact position and angle. It also involved a lot of post-production.
@pattymaher

What is your intended result?

When you're driving a car, you usually have a destination in the back of your mind. The art of the Advanced Selfie is just the same. If you don't have a plan before you set out, the result may turn out to be a wonderful journey of discovery, but you may feel you're just exploring aimlessly. There's a place for play and experimentation, and sometimes you'll just want to see where your art leads you, but sometimes you need a plan of action to get 'that shot'.

When planning, start by asking yourself the following questions:

- What would I like the viewer to feel when they see this image?

- How does this background make me feel?
 How does that relate to the purpose of my image?

- Is my outfit colourful and chirpy, is it dark, is it plain,
 is it sensual, is it strong?

- What is the purpose of the image? To uplift, to challenge,
 or to make people feel something particular?

- Where will the image be used and/or published? If it's
 for social media, you'll need to think about the framing;
 for example, vertical shots are ideal for Instagram.
 If the image is for your website or marketing material,
 a horizontal composition might work best.

One-snap wonder

Winning the lottery. Being attacked by a shark. Getting struck
by a bolt of lightning. Or finding a bar of gold buried in your
garden. These occurrences are all just as rare as you getting
a perfect self-portrait on the first click of the shutter.

In my experience, whether working in a professional photo
studio, taking my own Advanced Selfies or shooting for a client,
there's one rule that conquers all rules when it comes to getting
the perfect shot. And that is, you'll have to take a lot of photos.
Of course, you will get better with time. Sometimes I can get
a shot I love in the first five minutes. But even with all my

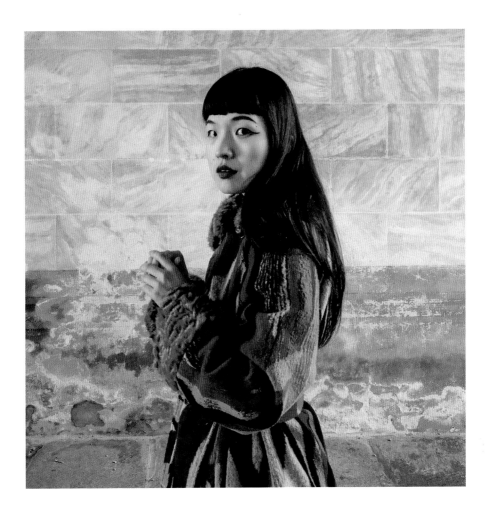

Ouwen Mori

What is so magic about this shot is that it looks as though it captures a single perfect moment: Mori's glance over her shoulder and the tumble of her hair being caught on camera as it happened. Mori works by setting the timer to ten seconds and shoots nine photos in quick succession during that period to capture single moments of ethereal beauty.

@ouwenmori_selfportrait

experience, there are times when I'll shoot for an hour before getting one that I adore. This is where patience and enjoying your artistic journey are very important, if you plan on keeping your sanity while taking self-portraits.

Preparation is key – don't just snap away aimlessly and hope for the best. Compose your frame, check your camera settings, test some poses to see how you might look best in the frame, and analyse your lighting. And, once that's done, spend a little time taking test shots to fine-tune your pose. This extra preparation may take you a little longer, but it'll be the secret sauce in maximizing your chances of getting the shots you love in the shortest time possible.

Sometimes it's all too obvious

From the start, the art of the Advanced Selfie has been making the images I produce look as high-fashion or as professional as possible, with nobody else but me doing all the work. When people see my Instagram timeline, I want to give the impression that I'm shadowed at all times by a professional photographer. I mean, if it works for celebs such as Kylie Jenner, and models such as Alexis Ren, why can't I look as though I'm playing on their level too?

I love it when people find out that I do everything on my own, completely solo, with no outside help. Not only does it impress my audience, but it lends a completely new dimension to my art. But it's not without its challenges.

Despite popular opinion, posing is hard. I bow down to professional models, who have spent years perfecting their craft

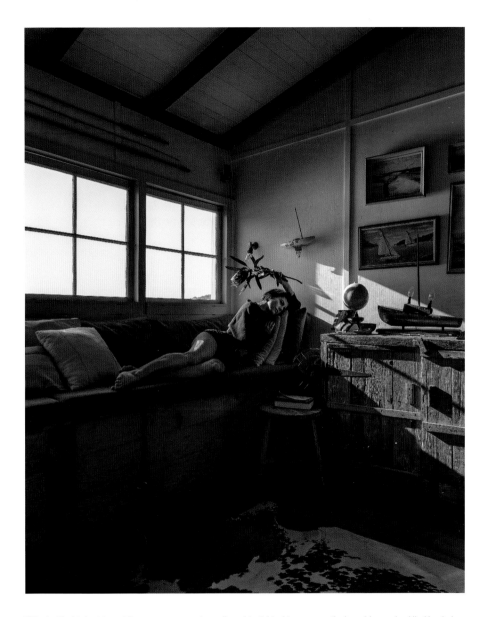

This shot had to be taken at the perfect time of day in order to capture the breathtaking shadows cast by the sun on the wall. Being a much smaller subject, I had to get the crop of the image just right to stop it from becoming cluttered. Then it was a matter of mastering the languid pose. Luckily, I landed on the idea of the flower to take it from basic to beautiful.

and have incredible bodily awareness, so that they can produce a perfect, flattering pose in seconds, almost every time. On the other side of the lens, being a photographer isn't easy either. You have to think about lighting, camera settings, background, model positioning, the story you want your viewer to perceive, the emotion in the image, and so on. Now, consider that when you become a self-portrait photographer, you're taking on both of these jobs. Yes, it's next-level difficult. (But, despite how hard it can be, the results are worth it. Stick with it.)

If your aim is to hide the fact that you've taken your photos yourself, to add that extra wow factor when the truth is finally uncovered, you'll have to keep a few things in mind. These are just some of the dead giveaways that a photo is self-shot:

- Being too close to the camera and not focusing on the composition (ensure you leave negative space in the top third of the image and on either side of you)

- The remote trigger or phone being visible in your hand

- Obvious over-editing of the image

- Overcrowding in the image

- Overposing and over-clenching of the mouth or jaw

- Not committing fully to your pose

- Breaking composition rules and not having a reason behind it (don't worry, we'll get into these rules shortly)

- Too much make-up, or amateur make-up

A big giveaway for someone who is a novice self-portrait artist is the excessive use of posing. I'm talking hands on hips, fake smiles, deer-in-headlights eyes, awkward or rigid hands, robotic posture or the infamous duck face. I always say that a great pose is usually uncomfortable to hold, but shouldn't be uncomfortable to view. No matter how hard it was for you to strike the pose, it should appear natural, and as if it flows. Achieve this by relaxing your hands or arms in a pose, by relaxing one leg while the other remains heavily posed, and so on.

Most importantly, it's all about the face. However painful the pose is to hold, your face must always appear as though you haven't a care in the world. If you can nail the balance between pain (the pose) and pleasure (the relaxation in your face), you'll be on to a winner.

Make or break your selfie

As with any art form, with selfies the rules are made to be broken. Most of what's in this book should be considered guidelines that I'm giving you to help you get the best results. But if you truly want your Advanced Selfies to stand out in the crowd, there's one thing you should try to inject into them all: the 'WOW' factor.

There's no hard-and-fast rule when it comes to injecting the wow factor into your images, and it can be as simple or as complicated as you like. But to start, I'd encourage you to study what makes images stand out for you. The next time you're scrolling through your Instagram feed or studying your favourite photographers, take note of what kinds of image stop

My first Advanced Selfie series went viral and reached more than 8 million people, despite the fact that I had no following. This is a feat that most artists will never achieve, but it was simply because I was prepared to see the world from both in front of and behind the lens. It's a perspective that very few people understand, and it adds a fascinating dimension to my work.

you in your tracks, or have you marvelling in awe. Then, try to emulate these special flourishes in your own images, or come up with your own. Think about how you can create something special that nobody has done before, or something so amazing that people can't help but take notice of it.

Take me as an example. I was born in Australia, but I have lived a large part of the last few years in Iceland. This is one of the strangest, most mystifying and most special places on the planet, and it's also the polar opposite of sun-soaked, warm, beachy Australia. Before I even came up with the term Advanced Selfie, I created a series of images in which I blended the idea of my home country with the landscape of Iceland. I would put on my bikini and go outside in the freezing snow of the Icelandic winter to re-create scenes that looked as if I was back home in Australia. From having a picnic on a blanket in the snow, to playing mini-golf, watering the garden, doing yoga and everything in between, this set of images stood out because the photos were special, unusual and different.

But not only that, people went crazy over them. My 'Bikini in the Snow' series was featured in magazines, TV shows, social-media publications and news outlets in dozens of countries all around the world. What started out as me unleashing my creativity in the snow turned out to be a worldwide sensation, and all because I added something a little special to my images, something that made people say 'Wow!'

You don't have to go as far as moving to the other side of the world, or putting on a bikini in the snow, but do spend some time thinking about how you can be different from everything else out there, or how you can amaze the people who see your images. Think different. Be different. And create different art.

Selfie confidence 101

You've probably heard people say that you should fake it until you make it. This is a good philosophy to keep in mind when thinking about how you show confidence in your self-portraits. No matter how nervous, jittery or shy you may feel when taking your own photos, there are subtle things you can do to give the appearance of confidence, to fool the viewer into seeing your inner power.

Of course, not every photo should show you looking supremely confident. If the aim of your image is to look vulnerable, delicate or sad, a confident pose may not be the best choice. However, lack of confidence is one of the most common reasons people give for being unhappy with their own images, so it's important to tackle it.

Here are a few tactics to help you hack your way to a more confident pose. Of course, keep in mind that, as with everything in this book, these rules can be reversed or thrown out if your intention is to achieve the opposite look.

- Learn your best angles and flaunt them.

- Keep a strong pose, but relax your face. It can be difficult to flex, angle, tense, strain and do everything else you need to do when holding a great pose, but sometimes the effort of doing all this will show in your face. This will not portray confidence. Control your pose, but relax your face. This will give the impression that you are in control, with a calm, confident demeanour.

- Don't look away. Looking directly into the lens will make you ooze confidence.

Charlène Irakoze
Confidence oozes from Irakoze here. Her eyes, heightened with make-up, are engaged and direct, and her open posture and the way her earrings rest on her shoulders give an impression of effortless assurance.
@cha.rlene_

- Smile with your eyes to help you avoid looking like a deer in headlights. If you have to channel a happy, powerful thought to get your eyes smiling, do it. Alternatively, if that doesn't seem to be working for you, engage your bottom eyelid ever so slightly. The results are the same.

- Relax and part your lips. Unclench your jaw.

- Pull your shoulders back and down. Good posture is key to appearing confident, but don't overdo it or you'll end up looking like a robot, or a tree trunk.

- Don't allow your sleeves to droop over your hands. It's cute, but often in real life you see children or teens doing it when they lack confidence. You wouldn't see someone like Fernanda Ly doing this when posing confidently in a photo. And, since you're Fernanda in the making, you should avoid this too.

- Smirk slightly. Leave the emotionless look to the professional models, since those of us without perfect cheekbones can't pull it off, and will look ridiculous if we don't do something with our lips or our eyes. Go for a small smirk at the very least, maybe imagining that you've just caught your crush checking you out, but you're trying not to let them in on the fact that you know.

- Angle your chin up, or straight on and fierce. Tilting your chin down or turning your head sideways slightly can look good, but it's not as confident as facing the lens directly.

- Own it. A subtle hint of reservation in your pose – even if it's small – will communicate to the viewer and reduce the confidence in your pose. Commit to the photo; after all,

it's just you and your camera. Remember, a bad photo isn't you, it's just a bad photo and you can always delete it. Don't over-analyse, and don't attach labels.

- Offer affirmations and encouragement to yourself. Even professional models have their preferred angles, and they hate a lot of their images, too. You're human, just like the rest of us. Be kind to the beautiful birthday suit you were born in.

In the end, it's important to remember that confidence is a state of mind that anyone can achieve. Just take a look at the internet these days; anyone of any shape, size, height, nationality, skin colour and age is being represented somewhere, and adored by many. There is no one specific way that you should look in order to feel beautiful or grateful for your appearance.

The real breakthrough in confidence will come when you stop faking it and start *feeling* it. If you can't seem to quiet that inner critic, or the nagging monkey mind that drags you down every time you attempt to feel confident, try deep breathing, self-reflection, meditation and surrounding yourself with people who see the beauty in you that you may not always see. Practices like this can work wonders.

And remember, although in our society it might seem as though high confidence and humility can't coexist, this isn't the case. You can be confident without developing an ego. You can be proud of your body and soul without demeaning others for the way they look and feel. You can channel your inner god or goddess without overshadowing anyone else. Whatever you do, don't fall into the societal trap of building your own confidence and then using that to bring down others who may not be as joyful to be in their skin as you.

It's not you, it's the perspective

Can you ever blame the camera for making you look bad? Yes! And it's all about perspective.

Your body shape, size and proportions change the closer you get to the lens in an effect called perspective distortion. It works on the principle that whatever is closer to the camera will become enlarged, and the effect can be magnified depending on the lens you're shooting with. For example, elements in the corners of an image taken on a wide-angle lens will be significantly distorted and look wonky, and not as they appear in reality.

Perspective shift can be disastrous for your image composition, but sometimes you can use it to your advantage. Here are some tips on how to use perspective – and how not to.

Don't photograph at shoulder height

The most common mistake I see people making is to take a standing photograph of themselves, keeping it at shoulder height. This results in the subject appearing to have very short, stumpy legs, because the top half of the body is closer to the lens, and so perspective makes it appear larger.

Shoot from the hip

When shooting a full body with the intention of getting the proportions right, try shooting from hip height. Even better, if you want your legs to look long, shoot from knee height and place your foot 20 cm (8 in) away from your body, and towards the camera. Through the magic of perspective, your legs will lengthen!

Control your arm size

Want to make an arm appear smaller? Twist your body slightly so that the arm is further back in the frame than your body.

Amplify your peach

To get a juicy peach without doing 1,000 squats at the gym every day, twist your hips and push your butt to one side, and closer to the camera. Like some kind of sorcerer, you've cheated your way to a rounder butt.

When sitting, shoot halfway up
When shooting sitting poses, ensure your camera is positioned at the midline of your body. Any photo taken from higher up using a camera that's tilted down will make your legs look tiny. Bringing your legs towards the camera (and not tucking them behind you) will make them look a million miles long.

Reduce/enlarge your chest

If you believe your chest is too small or too large (this applies to both males and females), you can tilt the top of your torso forwards or back to change the apparent size of it.

Get up close and personal

I love to photograph myself from up close and very low down. This is a 'go-to' for me, especially when the aim is to capture my feminine strength. However, this framing increases my hip size (which is great if I'm going for that plump peach vibe but not so great if you're not keen on adding extra width to your bottom or thighs) but if I fold at my hips and pivot forwards just a touch (with a straight back), my torso will go back into proportion and make me look like a powerful Amazonian goddess.

Be savvy when lining up for a group shot
Encourage your friends to avoid the edge of the photo to prevent anyone dealing with the perspective distortion, and also become the hero of the day by teaching your friends how to bring out their best angles with your posing advice. Lift each other up to ensure everyone shines.

Now that you're aware of how perspective shift can alter the way you appear on camera, you've won half the battle of achieving a flawless image.

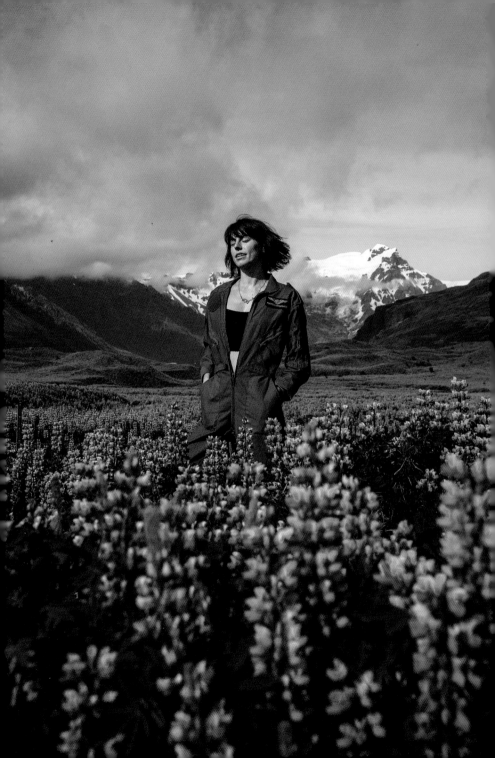

Photography

Photography: the essential rules

There are a few basic rules of photography that everyone must understand when mastering the self-portrait. Now that you're a model *and* a photographer, it's time to get acquainted with the basics.

Composition

The composition of an image – how you place objects or yourself within the frame – can make or break your work. There are many opinions about what makes a great composition, but what's most generally agreed on is that the image should be balanced and appealing to the eye. The frame should never appear cluttered, even if the aim is to convey chaos. There should ideally be some empty space (often called 'white space' – yes, even if it's not white) to give the eye 'breathing' room, and there should be detail that can be quickly comprehended.

If you're new to composition, try moving your physical location in the frame up and down, from side to side, and towards and away from the lens. Once you've taken a bunch of test shots, skim through the images and see which feel best. This is a good way to start composing the perfect Advanced Selfie.

We all have the innate ability to feel what's pleasing to the eye, even if we don't know the rules of photography. We're born with this skill, so start to use it.

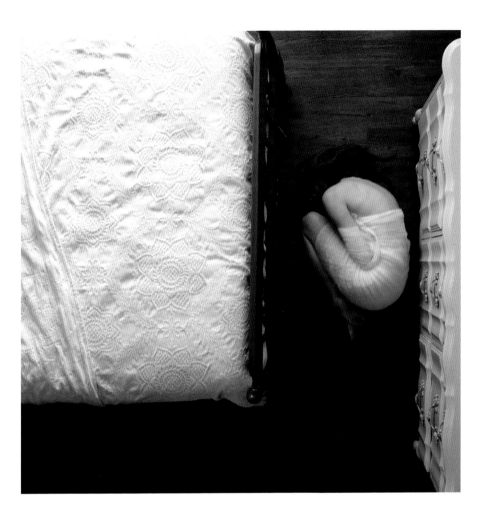

Nicole Campanello
Most of the 'action' takes place in the right-hand third of this self-portrait *In-Bloom*. The shapes help to frame the shot, and the bedcover creates negative space against the dark of the floor. The tightly curled, organic form of Campanello herself contrasts with the harder, linear shapes of the furniture.
@nicolecampanello

The rule of thirds

The best-known rule in photography is the rule of thirds. If you use only one rule, this is the one that will by default make your images aesthetically pleasing. It somehow provides immediate balance, without you doing much else at all.

To use it, imagine that there are two lines vertically and two horizontally across the frame, evenly spaced, creating nine equal-sized boxes. Along each of those imaginary lines and at the points where they intersect are the perfect places to put your subject. For example, you could place yourself immediately in the middle, with the top of your head touching the first top horizontal line. Or, if the image is a close-up, place the eye line across that top line. Leaving most of the top boxes empty provides the white space that is essential for a balanced artwork. You can also place the subject on either of the vertical lines, aiming to get the eye line where that vertical line and the top horizontal line intersect.

That said, once you've mastered the rule of thirds, you can break it – but only if you first understand why. All rules in photography can be broken, but there must be a good reason (eg. adding chaos or unease).

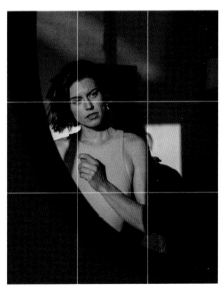

The images you see might seem chaotic, but you will almost always find that invisible rules are being followed to achieve harmony. One example is the extremely helpful rule of thirds. If we take care to place the subject in the centre of the frame, or at the intersection of the lines that divide the image horizontally and vertically into three, instant order is achieved.

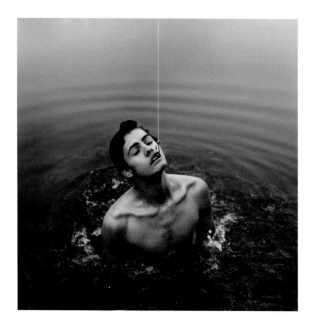

Brian Oldham
With the use of just three elements – water, main subject and fishing line – this stunningly simple, minimalist image is executed flawlessly. The mind can quickly grasp the details, and understand the story that is being told.
@brianoldham

Three elements

Although I developed this concept through practice for my own benefit, I'm sure it's not an original one. The aim is to have a maximum of three main elements in an image, to keep the clutter down and give you the best chance of all elements being in focus. For example, your three elements could consist of the main subject, a cow skull and a prominent blue sky. Or a couple, the sky and the ground. Or a messy bed, the main subject and empty walls.

This approach will create a minimal photograph with an air of professionalism. It's one of the key things I believe makes a photographer look skilled, even when they are just starting out.

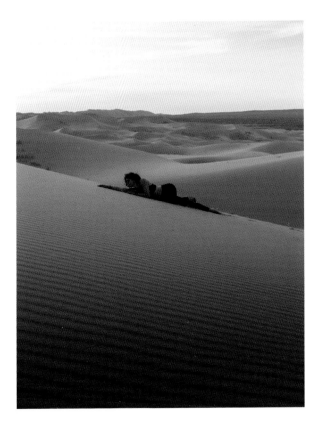

Scale highlights the fact that there is a lot more to life than meets the eye. My body is relatively small in the frame, while the sand goes on for miles and miles in the background, dwarfing me and emphasizing the vastness of the desert.

Scale

Scale provides the viewer with a frame of reference in terms of how everything is sized. It is a fun concept to play around with, because it can help to convey the story you're trying to tell. You can manipulate scale in photography by increasing or decreasing the size of the main subject (moving it closer to or further from the lens), or by photographing from unusual angles. If you're shooting outdoors and want to portray the stunning, endless landscape around you, stand back from the camera and capture yourself small in the frame in relation to the background.

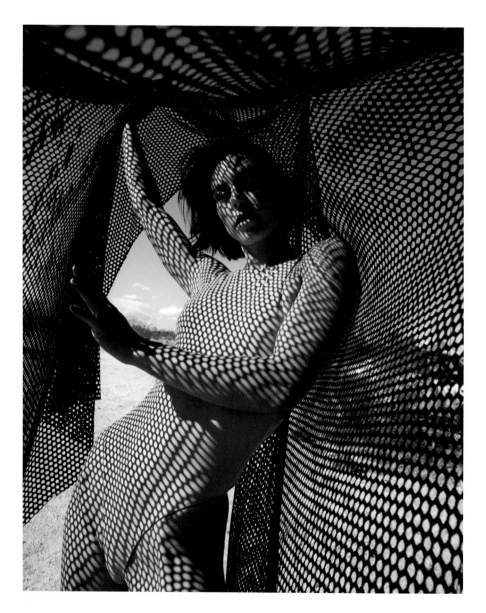

Shooting in the middle of the day can be tough because of the harsh shadows the sun creates, but you can use that to your advantage, as I have done here. I later turned the image monochrome to limit distractions for the viewer and highlight the beautiful patterns.

Monochrome
vs colour

Black-and-white (monochrome) photography is something you either love or steer clear of. But when it is done right, the results can be breathtaking. Personally, my favourite use for black-and-white photography is in portraits.

Don't be fooled into thinking it's easier than colour, though. In fact, it's much more difficult to master. When shooting in colour, you can mask a lot of technical mistakes, but monochrome photography emphasizes tonal contrast, shape, texture, form and quality of light, so you need to focus more on the fundamentals of your composition.

If you're set on mastering black-and-white photography, some cameras allow you to switch your settings to monochrome mode, and the display screen will show your images in black and white. As long as you're shooting a RAW file, you should get both a colour and a monochrome file, which is useful if you decide to add colour to your image while editing.

When editing a monochrome image, make it punchier by boosting the blacks and decreasing the greys. Also play around with contrast; the opposition between black and white will add interest to your image. Beware of pushing the contrast and blacks to the extreme, however. You're still seeking a natural approach, even if the image is finally presented in black and white.

Finally, please do stay away from having the image black and white and leaving one colour in the image. I've seen this done with umbrellas, dresses or shoes. To a beginner eye this usually does look appealing, but I have yet to see this done well without bringing the cheese to the table.

Master your camera's settings

If you shoot on a DSLR camera and are used to leaving it on automatic mode, it's time to learn your gear better and experiment with different settings. With a little practice changing shutter speed, aperture and ISO, you'll realize it's not as difficult as you thought, and you'll get new and exciting creative results. Tweak each variable slowly until you get your desired outcome, always leaving the ISO changes to last. My only initial ask is to ensure there is a part of your image in focus. Having the whole image blurred is an effect, but it's much harder and more impressive having a portion of the image blurred and a portion sharp.

Shutter speed

This is how long your camera shutter stays open to let light in to the sensor and create an image. Shutter speed has a significant effect on exposure – how light or dark your image is – as well as on its sharpness to create motion in your photos. You will have to experiment thoroughly using the f-stop and ISO afterwards, but the first setting to explore is the shutter speed.

Slow shutter speed

A slow shutter speed will give your photos motion. As a starting point, during the daytime put your shutter speed at 1/30, ISO at 100 and f-stop at around 10 to 16 (depending how harsh the light is). This will give you a good idea of how this slower shutter speed affects your daytime photo and you can continue tweaking from there. Same applies for night time photos. Using a tripod, try a 5-second shutter speed with ISO of 800 and f-stop around 5.

Fast shutter speed

This allows you to freeze motion, such as raindrops falling on your face or water coming out of a tap, and it will capture you as if you were a statue mid-stride when running at speed. Capturing a fast moment in time is something that our eye can't do, and that can create awe in the viewer.

Aperture

Similar to the shutter speed, the aperture controls the amount of light that enters the sensor, and dictates the depth of field of the image. The size of your camera's aperture is measured in f-stops. Making your camera's aperture larger or smaller will determine how much blur (or bokeh) the background of your image will have. The lower the f-stop, the wider the aperture and the blurrier the background. Having your subject far away from the background, or closer to the lens, will also make the backdrop more blurred. Traditionally, very blurry backgrounds are used in portrait photography to emphasize the subject. However, with a lower f-stop, it's even more critical that you take the time to ensure your desired focal area or subject is in focus. If you move just slightly back or forwards in an image with a low f-stop, it may make your nose sharp but your eyes slightly out of focus. When in doubt, always make sure the eyes of your subject are the sharpest point in the image – that is, unless your intention is to highlight something else, such as an object in a hand.

Small aperture
Set your aperture small, with a high f-stop such as f/8, f/11 or f/16, to create an image with a large depth of field where more elements will be in focus. You may need a slower shutter speed or higher ISO to achieve a normally exposed image depending on the lighting conditions in your environment.

Large aperture
A wide aperture set with a low f-stop number such as f/1.4, f/2 or f/2.8 will create an image with a narrow, much shallower depth of field. Fewer elements will be in focus allowing you to blur backgrounds and isolate your subject. You will be allowing more light onto your sensor so you may need to increase your shutter speed or reduce your ISO to achieve a normally exposed photo.

ISO

The third part of the 'exposure triangle', ISO, aids in brightening the image when you've maxed out the capability of the shutter speed and aperture. It is the last of the settings that should be changed when setting up your shot manually. ISO is my best friend when I prefer to keep my bokeh engaged but the surrounding environment is a little too dark. Keeping my f-stop low, thereby letting more light into the camera (around 1.4, which gives a wicked background blur), I also crank up my ISO to around 800 and I can keep the aperture low for a beautiful, delicate, artsy feel. Very often, if everything in an image is sharp, it will look extremely amateurish. When in doubt, keep your aperture as low as you can without taking your ISO above 800 (above this level, most cameras start to produce very grainy images).

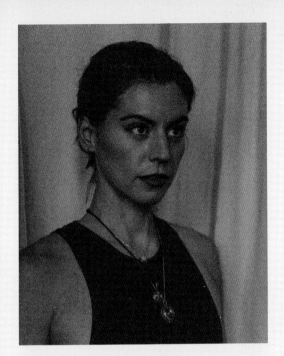

High ISO

High ISO settings such as 1600, 3200 or 6400 will increase light sensitivity and create brighter images, but they can also show a lot of grain.

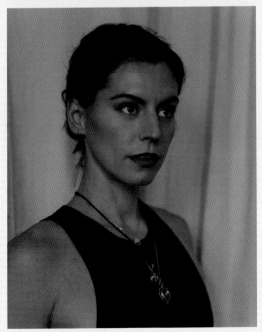

Low ISO

Lowering your ISO to settings such as 100, 200 or 400 will decrease light sensitivity and create darker images, but they'll appear sharper and have less grain. If absolute sharpness is a priority set your ISO to 100 (or as low as it goes on your camera) and experiment with a slower shutter speed and a slightly wider aperture (smaller f-stop).

Riya Jude
Jude posts with the hashtag #portraitswithmadness, and her images are simply posed, strikingly lit and imaginatively styled. In this one, she has applied bindis in the style of schoolgirl freckles. Combined with her expression of vulnerability, the image could be read as a comment on Hindu culture and women's place within it.
@born.madness

Opposite.
Olaia Macías
Here Macías uses light sparingly to focus attention on her main subject while the background gently falls away. To either side, large areas of darkness emphasize the drama of the central figure.
@huertaderegletas

It's all in the details

With all photography, the devil is in the detail. If you want to create a fully developed story or emotion in an image, it's important to get all the details and props exactly right. If you don't go this extra mile, something about the image will look off.

For example, do you want to look as though you're smoking? Make sure the cigarette is lit. Are you pretending to have a bath? Make sure the bathtub is pictured side-on, otherwise viewers will easily see that there's no water (or ultimately, you could actually take a bath – I mean, why not grant yourself a little luxury?). This also applies to emotions. It's easier to allow yourself to *feel* them (truly try to tap into ecstatic or painful memories and allow it to permeate your body), than to try to *fake* them.

Chase the light

Light is one of the most important tools for the photographer, but it won't always play by your rules. Light can make the same image taken at two different times of day contrast completely, and share wildly differing emotions with the viewer. The strength, tone, colour and movement of light all have a profound impact in photography.

Mastering light can be difficult, but it comes down to practice. If you are shooting indoors, experiment with natural light streaming in through a window to highlight your face, use lamps or candles to add a unique light source or use a tissue or thin strip of white material over a strong direct light source (such as a lamp) to diffuse light. If you are shooting outdoors, try capturing images at sunrise and sunset, when the light is diffused and colourful; for most people, shooting at midday, when the sunlight is harshest, isn't very flattering, unless of course you know what you're doing with the light (avoiding creating dark, strange shadows across your face or using shadows to enhance body parts instead of highlighting imperfections).

Storytelling

As I've mentioned before, you may initially hate taking your own portraits. However, once you fall in love with the process, or it becomes easy, you should attempt to experiment with storytelling – which will level up your photos beyond just pretty pictures.

Ask yourself: what is the subject (you) experiencing? What events have led up to this point? What subliminal messages or objects can be laid out in the composition, like clues that tell a story? What kind of outfit, wig, make-up or prop can you use to tell that story better?

Once you're able to tell a complex story with a single image, you've reached the realm of the true artist. They say a picture is worth a thousand words – but it's up to you to make that happen. A simple selfie will never make it as art on the walls of a museum or gallery, but a true piece of art that tells a complete story just might.

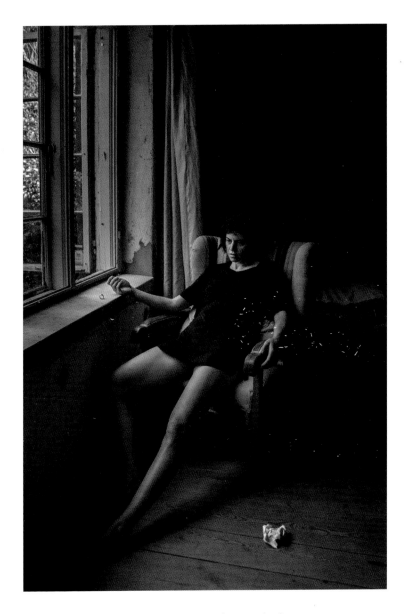

I took this image at a really
painful time in my life, focused on
heartbreak and the complexity of
love. I wanted to make it relatable
to many, not just to my situation, so
I introduced props – the ring and the
scrunched-up paper – to share the
story more openly.

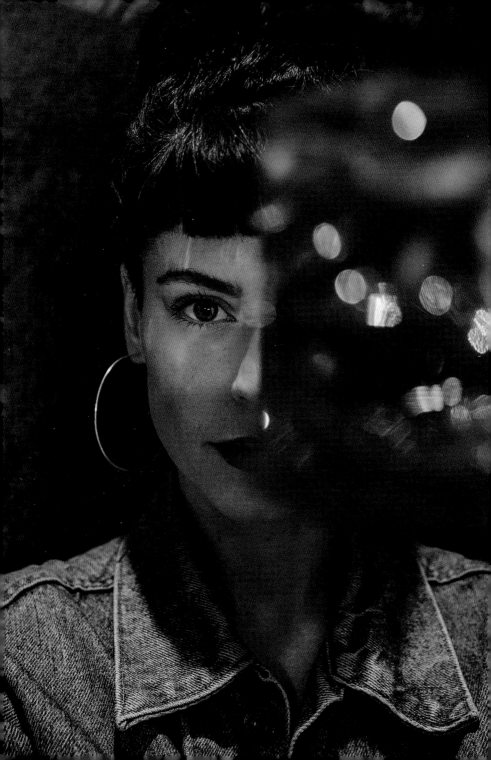

Get Creative

Get creative

Finally, it's time to get into some of the elements of the Advanced Selfie that you can implement to elevate your images instantly. This will boost engagement on social media and increase the excitement of the viewer.

Clothing as art

Creating art through self-portraiture isn't easy if you're dressing yourself in plain jeans and a T-shirt. If everyday items are what you put on, your photos will end up looking more lifestyle than high fashion or art. This doesn't have to be the case, but it's almost always the outcome for beginners.

An easy fix is to go for garments that are block coloured in natural hues. Black, beige, white, khaki and shades of 'nude' or skin are the simplest. For me, as a minimalist and someone who travels without a huge suitcase, it's often not possible to have the 'right' outfit with me, so simple, classic pieces generally work best.

Finally, if you're comfortable, removing all your clothes – real nudity (honestly, even partial nudity) – is very often an easy way to elevate your images into the realm of art. You don't need to have a specific body type to take naked portraits of yourself, but learning to work with what you have is key. Go back and study your body in the mirror and see what angles are most flattering for you, then try experimenting with strange angles that tell a story of sadness or grace, for example, and see how you feel when you pose your nude body that way. If you're happy with how your body presents itself, feel free to incorporate that pose into your images.

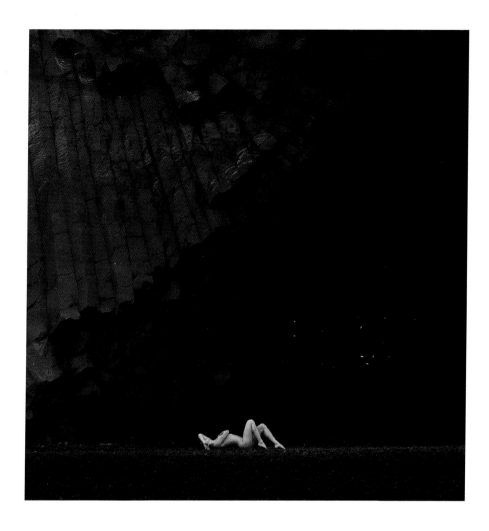

I created the 'Nude vs. Nature' Advanced Selfies because I felt wearing clothing in these stunning natural locations would be distracting. Here I am at Reynisfjara beach in southern Iceland, underneath the perfectly sculpted basalt columns, the curves of my body making a contrast to the rigid lines of nature.

Rosie Hardy
Living out lavish childhood
dreams is part of creative
expression, and clothes can
be used for that. Here Hardy
wears a white gown that stands
out against the background of
red foliage. The way the leaves
encroach on the dress and
the way Hardy plays with them
creates a narrative that we
relate to fairytales and fantasy.
Escape from the everyday
and create an artistic escape
without restrictions.
@georgiarosehardy

Dress up like ...

Whether you've never experimented much with clothing or
you have an enormous wardrobe, it's time to take it up a level,
to ramp up your art. Experiment with additional layers, over-
the-top jewellery or headpieces, and anything else you can
think of that will add interest. As a general rule, if it doesn't
look like something you'd see worn on the street, it'll add
a ton of interest to your image.

Take the catwalk as an example. At most high-fashion
shows, you'll see models wearing extravagant, surreal clothing
art pieces created by designers to grab attention and show
off their new design language. However, only a small fraction
of what's seen on the catwalk makes it into stores. But you're

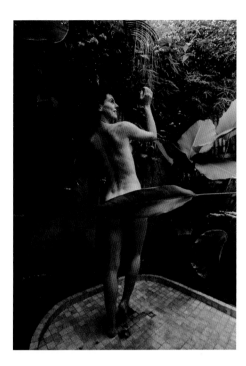

Clothing can be a timestamp for the image. Minimal or no clothing helps you make your photograph timeless, allowing future generations to see it more as art than as a documentation of current events. Here I used a sneaky little Adam and Eve leaf to cover up my privates, creating a visual wonderland.

not going for an 'off-the-rack' look – you're trying to grab attention. Channel your inner fashion designer and create an outfit worthy of the catwalks of Paris, Tokyo or Milan.

When dressing up extravagantly, it's important to keep your background to a minimum. Lavish outfits work better against backdrops such as parched deserts, snow-swept plains, industrial studios or unassuming brick walls. Let yourself be the focus, not the backdrop.

Dress down like ...

But can you also add interest with less? Definitely. Let's look at minimal clothing options that are generally not suitable for

everyday life, but are perfect for expressing yourself in art. You don't have to go out and buy something new to create a memorable outfit. Sometimes you can achieve art by doing nothing more than wrapping yourself in a curtain. As always, imagination is key.

- Wrap yourself in nothing but a feather boa? That works.

- No clothing under bed sheets, with just a towel around your head? A perfect way to set a scene.

- Wrap yourself in nothing but a shower curtain, or conceal yourself behind deep, dark shadows? Brilliant.

- A shoot in the jungle where your private parts are covered by leaves? Stunning.

- Using throw rugs, blankets, bed sheets or scarves as makeshift skirts or body wrappings? Perfection.

Embrace the soft sun on your skin

The delicate light of sunrise or sunset can be pure gold for portrait photography. The soft glow it casts on the skin enhances the complexion, reflects beautifully in the eyes, and can suggest depth, fantasy and dreaminess. It doesn't cast harsh shadows, and you get the added benefit of stunning natural colours painted on mountains, trees and any other landscape in the background. For the beginner, it is a reliable ally in

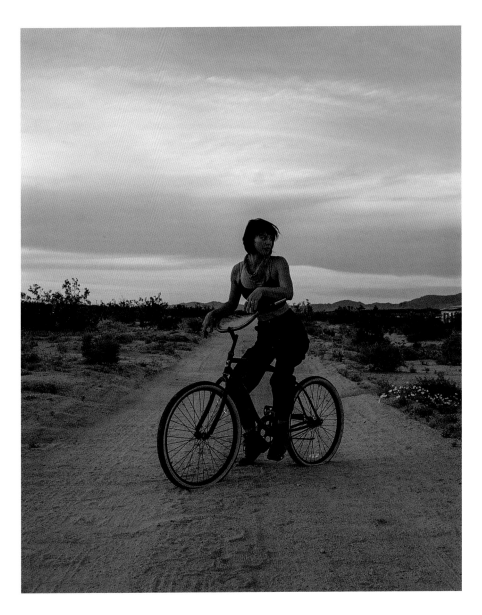

Soft light such as sunrise or sunset light is the most bulletproof lightsource. This light eliminates harsh shadows, which often time can be the enemy of beauty. It helps produce subtle shades of colour to give a harmonious palette.

making your images look effortlessly beautiful, and that
will give you the confidence to continue practising your
self-portrait art.

It's all about the drama

Ready to break some more rules? Having said all that, far too
many landscape photographers shun any time of day apart
from sunrise or sunset, simply because the light is too harsh.
However, mastering elements of photography that most people
don't can add something truly special to your images. Harsh
midday sun can strengthen an image, creating a stark contrast
between light and deep shadow, and offering a level of madness
and mystery that softer morning or evening sun can't provide.

Playing with these harsh shadows can be an extremely
rewarding way to practise your art. Stand behind leaves or
branches that cast shadows in your close-up portrait shot, to
add interesting shapes to your face. Or find objects that cast
prominent shadows, and let them cut through your face, to
create tension in your image. Face away from the camera and
add droplets of water to your back to mimic sweat, to give
the impression of fatigue or heat exhaustion. Stand under a
piece of fabric with lots of holes in it, so that it casts interesting
shapes and shadows across your body. Or sit under a palm leaf
so that its shadow paints your body with patterns of lines.

You can also tilt your head up, close your eyes, raise one
hand towards the sun (without casting a shadow on your face)
and pose as though you're trying to block the sun from your
eyes. This is another of my favourite 'go-to' poses.

Niela Lis
Not only is the light brutally harsh, but also the photo is black and white, which emphasizes the drama. Lis illuminates the side of her face, creating a shadow along the jawline to show the contours. The trick works well for all genders.
@niela.lis

An important note when learning to play with shadows: initially lift your face high towards the sun no matter what pose you're in (unless your face is meant to be hidden). If you don't, you'll be left with harsh shadows across your face, and it can be difficult to make those look right. As you become more comfortable working with harsh light, then you can start enjoying incorporating shadows on your face.

Attitude is everything

Smiling selfies may seem cute, but ask yourself how many times you've seen a big smile in a copy of *Vogue*, or a Renaissance painting. Not many. Sure, it's a shame the human smile isn't more celebrated in art, but it seems society has reserved it for family photos and group selfies.

If you want to move into the world of high art (and of course you do), you need to take inspiration from high-

Nassia Stouraiti
Amazingly, the white shapes on Stouraiti's face don't distract from her attitude in this shot. In fact, they draw the viewer deeper into her eyes, a key part of her nonchalant expression here.
@nassias_

fashion photography. And right now, attitude is everything. Being nonchalant and looking a little bored are the current fashion, so we must emulate that to a certain extent. It may help if you dream up a persona that can channel your inner badass when it's time to take self-portraits. Think of characters such as Beyoncé's 'Sasha Fierce' or Eminem's 'Slim Shady', and create one for yourself.

Feelings are friends

In everyday life, we mostly see one side of the people we encounter: the smiling, happy person. But where's the rest of them? Emotion is the most powerful thing you can draw on to channel something special in your images, which will fascinate your viewers and draw them in. This is because emotions reveal stories, depth and drama, which are like magnetic attraction points for humans.

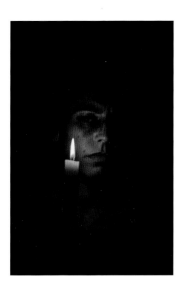

I was going through a very emotionally tough time in my life and I decided to embrace those feelings and create art through pain. The candle provided the perfect light source, which illuminated a slither of the image, keeping the overall vibe dark and moody.

We've all gone through emotional pain, some more than others. You may have tried dealing with it in conventional ways, and I hope you have made progress. But I'd like to propose, if you're open and willing, that you use your emotions in your art to dive deep into the pain – you *might* find it therapeutic. I don't know your personal situation; I can only speak about how this process helps me. Having gone through a near break-up myself, I used my heavy heart to create amazing art that it truly hurts to look back on, but it did help me to feel my feelings fully. The photos and videos I create during painful times are some of my most heartfelt, and often my most original, thought-provoking and captivating work.

Remember, none of these images has to be shared with anyone, let alone the whole world. It can be as simple as you expressing your art to only yourself. Bear in mind that some of the most powerful pieces of art have captured heartbreak, turmoil and tragedy. Once your pain is healed, helping others to heal through witnessing your work can be a true honour. Normalize feelings, if you feel called to do so.

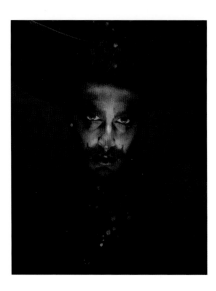

Germán Luque
Play around with who you are. You don't have to be the same person in every post. Who do you see in this self-portrait, *Broken Smile*? An interstellar warlord, a futuristic psychic or something else? Do you think that's really Luque? Notice how the lighting works with this, as well as the make-up.
@germanluquephoto

You are the unexpected

As I've already mentioned (see page 31), you should allow the Advanced Selfie to become a reason to explore the shadow part of yourself, or the sides of your personality that you've so far suppressed. This will allow you to create work that isn't expected of you.

In day-to-day life, I'm weird, hyperactive and over-the-top, with a serious dash of the tomboy. So naturally, my images should reflect that, right? Wrong. Most of them are sexy, beautiful, seductive, feminine, serious and moody. To see the contrast, first take a look at my Instagram (@sorelleamore) and then seek out my YouTube channel (Sorelle Amore). You'll see a clear difference between my personality and my art. But this contrast exists because I've learned to channel parts of myself that are suppressed in daily life.

I encourage you to use this as a tool when creating your own art. But don't channel your shadow self, or a different version of you, because you want others to perceive you in a certain light. Do it for yourself, so that you can live out a fantasy of being the sexiest, dirtiest, angriest, most provocative or most experimental person you want.

Let the lips do the talking, but not the pouting

Just like the eyes, the mouth can tell a thousand stories without uttering a single word. Firstly, cancel the pout or the duck face. It doesn't look good, it's never looked good and it's never had a place in art, fashion or other high-end imagery. It will also make you look childish and immature, which is good only if that's the character you're trying to play.

Instead, relax and experiment with expressions that are more natural for the mouth – those that would be used when channelling specific emotions. If you're uncertain about how to achieve the results you want, spend a week photographing only your mouth, tongue and teeth while trying to portray different emotions, and study what you love, and what you don't love. Dress up your mouth with different props, such as make-up, flowers, fruit or other objects. With a little practice, you'll become a master of your mouth.

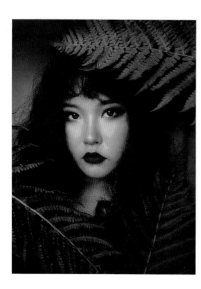

Anura Liz
Engage your eyes just as Liz does here and you'll create an image that has power and confidence. Be aware that as soon as you present the viewer with an engaged pair of eyes, that's what will catch their attention, so don't clutter the rest of the composition. The fern leaves give the image just a dash of extra visual interest.
@anura_liz

To look, or not to look, that is the question

When do you look into the camera, and when do you look away? It's a question you'll ask yourself a lot when starting your Advanced Selfie journey. And, as always, practice and experimentation make great progress. I always try a variety of eye positions when striving for a specific image, from looking directly at the camera, to looking sideways, to looking up out of the corner of my eyes, and even keeping my eyes closed. With enough test shots, you'll find what works.

As I mentioned earlier, a general rule of thumb is that looking directly into the camera conveys confidence and certainty. For dreamier shots, or those in a fantasy setting, you'll want to act as if the camera isn't there, to bring the viewer into the scene as an observer.

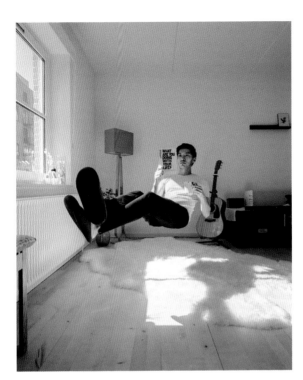

Jérémie Kung
In this quirky shot Kung has placed himself just beyond the middle ground, in the back third of the picture space, to give the photograph depth. But of course it is his use of Photoshop to remove his chair that makes the image really striking.
@jeremiekung

Avoid the middle ground

A common mistake beginners make is their positioning within the framing of the photograph. They end up in something of a middle zone, which breaks the rules of photography and results in a finished product that isn't pleasing to the eye. Ensure that you follow the rule of thirds, and step closer or slightly back for the ultimate composition.

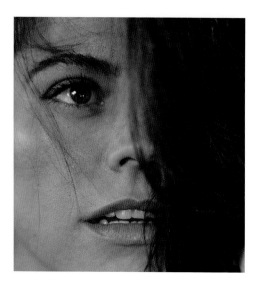

Small elements of ourselves can be separated and made the focus of the image. There's enough interest and beauty in the galactic details of the eye or the soft curvature of the lips to create a stand-alone art piece. And if you're not so confident showing off your whole self, it can really help to concentrate on the tiny details instead.

Your face is a landscape

The details and angles of a human face can be mesmerizing. Capture them however you can. A good way to learn this is to take intentional extreme close-ups of yourself, where the entire frame is filled with your face, from your chin to the top of your head. These extreme close-ups can be used to amplify eyes, nose or mouth, to showcase interesting make-up, or to focus on a particular expression.

Just as with the mouth exercise I've just mentioned, conduct an exercise where you spend a week or so doing nothing but photographing your face close up, with variations in expression, make-up, emotions and props. You can also play around with mirrors, or other ways of capturing a reflection, which can add interest as well as help you learn to better capture the human face.

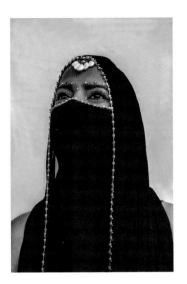

Anjali Choudhary
Reds and blues sit opposite each other on the colour wheel, so they contrast with each other. The deep red here is bold, and it's heightened by the opaque cyan background.
@anjalichoudharyblog

A clash of colours

Learning the art of colour theory, or why certain colours work better together (or oppose each other), can improve your art drastically. Although our cameras may be modern technological marvels, colour theory is definitely not a new concept. In fact, the way we think about colour today, and the way certain colours harmonize, clash and work with each other, is all based on the first colour wheel created way back in 1666 by Sir Isaac Newton – yep, the guy who came up with the theory of gravity after seeing an apple fall from the tree. Colour theory is the premise that some colours naturally work better with each other than others, that colours can complement each other, and can radically transform a scene or its mood.

But how does this apply to you and your self-portrait journey? Colour theory can be embraced fairly simply, or in a much more complex way. For example, it's widely accepted that red expresses passion, speed, aggression and

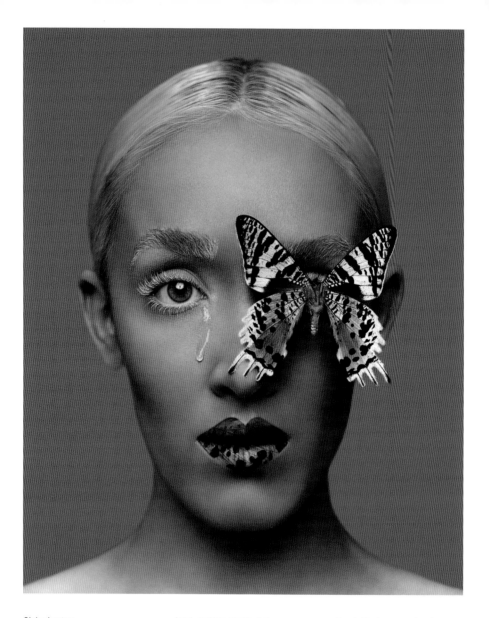

Claire Luxton
For contemporary artist Luxton, 'colour has the ability to communicate on a non-verbal level, evoking emotions: a memory, a smell, a nuance in time.' In this work *Butterfly Tears* (2020), a pink background and bright rainbow of colour in the foreground seduce the viewer, but they are contrasted by the single tear communicating sorrow and anxiety. **@claireluxtonart**

fiery emotion; yellow is used to embody optimism, happiness, energy and warmth; and green symbolizes health, tranquillity, luck and jealousy. Regardless of the composition of your image, it's important to know how we've been programmed to react to certain colours, and use them in your images to transmit a particular story or mood more clearly.

In more complicated terms, colour theory describes how certain colours work well in combination with each other to enhance a scene, while others mix about as well as oil and water. Red and yellow work very well together, and you can see this combination in brand logos and advertising all around the world. Blue and green are often seen together, as are yellow and blue. Some colour combinations which might be harder on the eyes (but of course, if you love wild colour combinations you might disagree) are red and orange, purple and yellow or green and orange.

But don't think that you must stick to colours that harmonize – you can create significant impact using shades that generally aren't a match. You could make yourself stand out against a bland or colourless background by dressing in an angry assortment of clashing, mismatched colours, or use Hollywood's tried-and-tested blend of orange and teal to make yourself pop out in a scene. You're limited only by your imagination, and the effect you're trying to create in your artwork.

The simplest and most effective tool to have in your arsenal when it comes to mastering colour is the humble and trusty colour wheel. Begin to experiment with the wheel as part of your artistic expression, understanding that any colours opposite each other on the wheel are contrasting and any colours two spots away from each other are complementary.

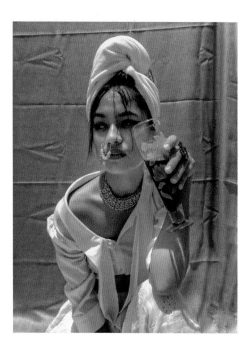

Richa Shahi
Shahi's casual pose and the towel wrapped around her wet hair are the first thing you see when you look at this image. But she's also wearing full make-up and jewellery. It's that kind of duality that will give your portraits an added layer of interest.
@richashahii

Polished beauty vs a rebel without a cause

Contrast is one of the most rewarding tools for a photographer to play with. For example, a rebellious figure in a sea of porcelain perfection showcases the way many of us feel when we're expected to put on a happy face for the world. Or the perfect prim-and-proper subject surrounded by a chaotic scene may reveal something completely the opposite. Try to steer clear of having only a single dimension in your art, otherwise it may come across as bland and lack novelty. An 'out-of-place' element may be exactly what you need to elevate your work.

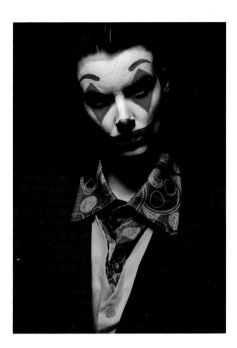

Vanessa Woitenas
In this portrait, *Joker*,
Woitenas uses full-on
make-up to create
a familiar menacing
character. Look beneath
the make-up and you see
a stern expression which
complements the bold
lines and shapes outlined
in make-up.
@lejoninna.art

Make-up should be expressive

Make-up can be a photographer's best friend. A businessman in a suit photographed in the middle of a bustling city and wearing clown make-up will surely draw the viewer's eye. A naked woman in distress but who is wearing flawless make-up may create confusion or uncertainty, in order to tell another story. A bare face with no make-up communicates vulnerability or humility, and that alone can be a powerful tool to create a bond with the viewer. There are endless examples online of how to create a story with make-up.

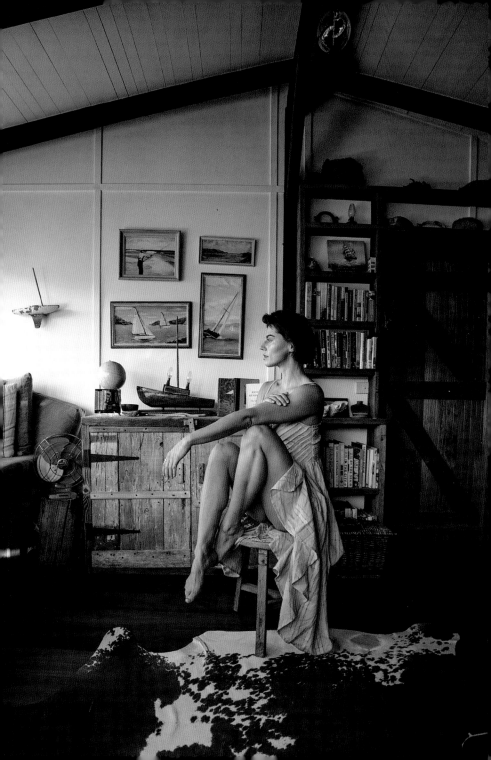

Take It One Step Further

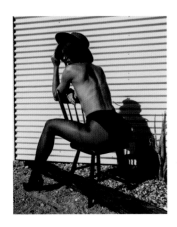

This is one of my most popular series so far. I don't wear heels in everyday life, but I wanted to celebrate the new grown-up, womanly version of myself that I had just discovered. I played with shadows and outfits (or lack of) and an alter ego was born. It's a joy to look at these photos when I'm feeling down about myself, as a reminder of the queen I can be.

How many examples are out there?

When unleashing your creativity, it can be beneficial to think of yourself as nothing more than the subject of an image, or a blank canvas. You can simply be a model in an artwork. Sometimes, the greatest art is created when you detach completely and see yourself as a character in a film or a mannequin in a shop window. When you perceive yourself in this light, there's no limit to what you can create with that blank slate.

If you ever get stuck, inspiration is always just around the corner. Flick through some fashion magazines, wander through an art gallery, take a stroll through a park or the countryside, or scroll through your Instagram feed. Find what you love, or what captures your attention, and create your own, beautiful, unique version of that. Most of all, have fun with the process.

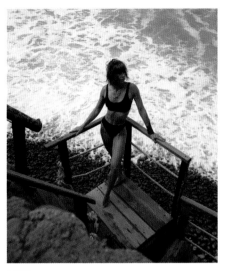

RAW image
How many different photos can you end up with, simply by altering the colour? Here is the raw, unedited version.

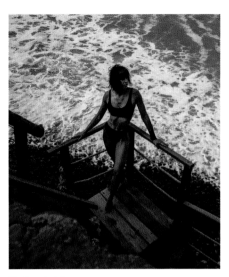

Black and white
When turned black and white, it's instantly moodier, and you concentrate on the details of the foam, the shadows and the light hitting my skin. To me, this conveys glamour.

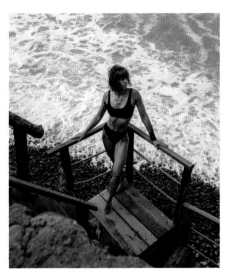

Vintage
Here, I applied a vintage feel to my editing. The contrast of orange and teal makes this image stand out to me most. But by bringing out the orange hues, I also gave myself an instant tan, which I'm not mad about.

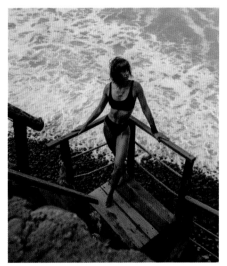

Colour reduction
I love taking colour away from images and leaving a limited amount that helps to create a very specific vibe. In this case, the warm brown hues give a rich vintage feel.

From a selfie
to an art piece

Would a sculptor say his artwork is finished before it's mounted? Or would a composer consider her orchestral piece perfected without the musical input added by having it played on real instruments? Probably not. And it's the same with images.

This is where I encourage you to fall in love with photo-editing programs such as Lightroom and Photoshop, which offer endless possibility for tone and colour correction. When an image comes out of your camera, the colours are generally realistic. There's nothing wrong with that, but there's a lot in terms of tone, emotion and feeling that can be added with simple colour tweaks or minor edits to the scene. The beauty of this is that you can add to your art dimensions that simply wouldn't be possible if you just accepted what came out of your camera.

During my time learning to photograph, I sometimes spent eight hours or more a day playing around with the endless settings in Lightroom, to transform my art completely. Today I can't imagine releasing an image without at least altering the colours slightly, to give them the perfect tone and feel. If you want your images to become irresistible, I encourage you to do the same.

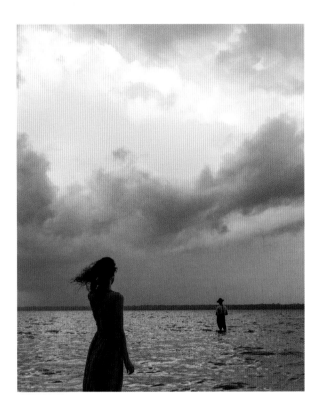

Elle-May Watson
This photo was taken before a huge rain storm and to evoke that particular feeling of summer rain and tropical storms, Watson has warmed up the highlights and shadows with yellow and orange – the photo had much more blue and pink originally.
@ellemaywatson

How to edit

The way you edit your images will come down to personal preference, after you've tried out a few approaches. My only word of warning is: don't necessarily trust your personal preference right away. The eye of the beginner isn't adapted to what makes great editing great. Initially, you'll probably boost the saturation when you shouldn't, increase the clarity too much, or make your image black and white when that just doesn't suit. Trust me – I've made all these mistakes myself. But with practice, and a lot of time, you'll begin to know what works.

Study what those at the top of their game do, and emulate that at first. Eventually you'll find your own style based on that. I know it may be difficult directly copying others, but eventually what you're emulating will gain a life of its own in your work.

The simplest way to get incredibly well-edited images at the start is by using Lightroom presets, which will edit your images to perfection with one click. Most famous Instagram photographers sell their own presets so that you can copy their style, which is something I did at the start of my journey. And, of course, I now have my own presets if you want to emulate my style in your images. You can find them at www.sorelleamore. com/shop – they're usable on desktop or mobile devices.

Create a series

Creating a single image after a spark of inspiration is great. But have you ever considered turning that one concept into a series? Creating a series can prolong or extend an idea, and turn it into a set of artworks or pieces of content for your social media. The common thread could be an outfit, a mask, a setting or a scenario, with slight alterations in each image. You can also tell a longer-running story across several photos, keeping them in a set. The next time you create a beautiful image, ask yourself: 'Could this be the start of a series? How?'

I smiled from ear to ear when taking these photos. What a simple way to have a never-ending photography series. Change your clothes, change your props and the grass will forever be the perfect backdrop for your drone-assisted Advanced Selfies.

The Advanced Selfie in everyday life

Life is precious, and life is beautiful. But for all of us, one day it will end. We've all heard it before: there's nothing in this world more important than those things that can't be replaced, such as our friends, loved ones and family.

The Advanced Selfie is an incredible tool for celebrating yourself. But once you start to master this art, it can be a fantastic way to capture people in your life whom you love immensely, who will one day depart this Earth. Not only that, but it's a way of preserving yourself so that your children and future generations will remember you. A simple family selfie can be elevated into art once you're able to put these skills into practice with a group. And once you give your friends and family guidance on how to appear on camera the way they'd love to be captured, everyone will be satisfied.

As I said at the start of this book, the Advanced Selfie is much more than it appears. So use this tool to capture the most important parts of your personal history, so that they'll last forever.

No photo I've ever taken is more special to me than this one. My man and I had just been gazing at the most breathtaking sunset. I quickly asked Leon to hold my hand and convey strength in our pose to show our unbreakable bond. It's the simplest pose, but it speaks volumes. I will cherish this image forever, because it captures our personal love.

Index

Page numbers in **bold** refer to portrait captions.

Where to go next

There is more information on everything you've just read on my website, www.sorelleamore.com. There you will find more resources to help you master your own self-photography and learn more about the Advanced Selfie. You can become part of my Advanced Selfie University by going to www. advancedselfie.co and joining thousands of other students who have done the same. Finally, feel free to find me on Instagram and YouTube at @SorelleAmore, and please tag #AdvancedSelfie in all your images online so that I can find the beautiful art you create.

About the author

Sorelle Amore is a photographer, filmmaker, influencer and business person who since 2016 has inspired her millions of followers around the globe to ditch the idea of being a starving artist.

Sorelle has been featured in numerous global media outlets including Forbes, Business Insider, Cosmopolitan, Buzzfeed, Daily Telegraph, News.com.au, and many more.

Acknowledgements

Sometimes when I realize I've created a global movement around the Advanced Selfie it makes me giggle slightly, but then I remember how much this weird little thing changes lives. This warms my heart. I'm glad a 'silly idea' of mine has been able to do so much good.

Thank you to everyone who has embraced this art form, which has allowed so much freedom of expression, and created images of themselves that more accurately reflect the vision they hold in their mind's eye.

Forever thankful to my handsomest boyfriendo Leon Hill for supporting my business ventures. As well as being much more savvy with the written word than I am, and for correcting my thoughts to be much more cohesive in this book.

Thanks to my parents for insisting I live a strange life, which has meant I've never put limitations on what I can and cannot do. This book is the result of your unconditional belief in me.

Thank you to my first and most important photography teacher and best friend Sasha Dobies from Sherbet Birdie Photography. I would not be where I am without your guidance. To all other mentors along the way, thank you for your encouragement and belief in me.

And mostly, thank you to all of my friends on social media (I won't ever call you fans or followers). I LOVE our community and how we all thrive together, and make the most of life. We're awesome.

Embrace your quirks, embrace your current human shell. Now go out there and do great work.

Sorelle

Picture Credits

The author and publisher would like to thank the following artists for permission to reproduce their images in this book. Every effort has been made to credit the copyright holders, but should there be any omissions or errors, the publisher will be happy to correct them in subsequent editions of this book if notified in writing.

p.13 Alexandra Nowak (@lex_nowak), p.19 Cinthya Bufano (@adrian128k), p.22 Lenke Magyary (@lenkexplores), p.27 Aida Đapo (@iddavanmunster), p.35 Bronte Huskinson (@frombeewithlove), p.60 Tana O'Hara (@tana-ohara), p.63 Mari Moore (model, influencer and entrepreneur, @mari.moore_), p.64 Maya Washington (@mayasworld), p.65 Charlène Irakoze (@cha.rlene_), p.71 The Hills, Patty Maher (@pattymaher), p.73 Ouwen Mori, self-portrait, Certosa di Pavia, Italy, 1/2020 (@ouwenmori_selfportrait), p.81 Charlène Irakoze (@cha.rlene_), p.93 Nicole Campanello (@nicolecampanello), p.96 Brian Oldham, self-portrait, (@brianoldham), p.106 Riya Jude (@born.madness), p.107 Olaia Macías Rubio (@huertaderegletas), p.114 Rosie Hardy (@georgiarosehardy), p.119 Niela Lis (@niela.lis), p.120 Nassia Stouraiti (@nassias_), p.122 Broken Smile, Germán Luque (@germanluquephoto), p.124 Anura Liz (@anura_liz), p.125 Jérémie Kung (@jeremiekung), p.127 Anjali Choudhary (@anjalichoudharyblog), p.128 Butterfly Tears (2020), Claire Luxton, Contemporary Artist, @claireluxtonart, p.130 Richa Shahi (@richashahii), p.131 Joker by Vanessa/@lejoninna.art/Vanessa Woitenas, p.137 Elle-May Watson (ellemaywatson).